On
Homo rodans
and Other Writings

On
Homo rodans
and Other Writings

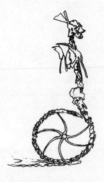

Remedios Varo

EDITED AND TRANSLATED BY
MARGARET CARSON

WAKEFIELD PRESS
CAMBRIDGE, MASSACHUSETTS

Wakefield Press, P.O. Box 425645, Cambridge, MA 02142

This book was set in Garamond Premier Pro and Helvetica Neue Pro by
Wakefield Press. Printed and bound by Sheridan Saline, Inc., in the United
States of America.

ISBN: 978-1-939663-91-7

Available through D.A.P./Distributed Art Publishers
75 Broad Street, Suite 630
New York, New York 10004
Tel: (212) 627-1999
Fax: (212) 627-9484

10 9 8 7 6 5 4 3 2 1

CONTENTS

EDITOR'S INTRODUCTION

This reincarnation was not easy. After my spirit had passed, first through the body of a cat, then through that of an unfamiliar creature belonging to the world of velocity, I mean the one that passes through us at over 300,000 kilometers per second (and which, therefore, we do not see), I went on to land, inexplicably, in the heart of a piece of quartz.

—Remedios Varo, "My dearest sir"

Maria de los Remedios Alicia Rodriga Varo y Uranga was born in 1908 in Anglès (Catalunya), the second of three children and the only daughter. Her mother, Ignacia Uranga Bergareche, was from the Basque province of Gipuzkoa; her father, Rodrigo Varo Zejalvo, a hydraulic engineer, Esperantist, and freethinker, was from Córdoba, Andalusia. Varo's artistic gifts were apparent early on, and her father encouraged her interest, giving her lessons in drawing and in the use of drafting tools. His profession took the family to different parts of Spain and to Morocco during her childhood, but by the time Varo was a teenager they had settled in Madrid. There she could spend time in the Prado Museum, where Hieronymus Bosch, El Greco, and Goya were among her favorite artists, and—unusual for a woman at that time—could begin her formal artistic education, first at the Escuela de Artes y Oficios and then at the prestigious Real Academia de Bellas Artes de San Fernando, where she enrolled in 1924.

After completing her degree in 1929, Varo married a former classmate, Gerardo Lizarraga, and began to move in vanguard circles, first in Paris and then, upon her return to Spain in 1932, in Barcelona, a center for the avant-garde. Her marriage to Lizarraga had dissolved by then (though they remained lifelong friends) and she became romantically involved with the Catalan Surrealist artist Esteban Francés, with whom she shared a studio on Plaça de Lesseps. In the summer of 1935, the Surrealist artists Óscar Domínguez and Marcel Jean, in Barcelona on a visit from Paris, went to see Varo and Francés in their studio, and the four collaborated on a remarkable series of *cadavres exquis*, works that first placed Varo on the Surrealist map.[1] Varo also exhibited several paintings in the landmark *Logicofobista* group show at the Galeries d'Art Catalònia, organized in May 1936 on the eve of the Spanish Civil War, by the Catalan vanguard group ADLAN (Amics de l'art nou).

In July 1936, Varo met the French Surrealist poet Benjamin Péret, who had come to Barcelona to support the anarchist cause. By the spring of 1937, with conditions worsening in the city, Varo left Spain to join Péret in Paris, where she met André Breton and other artists and poets in the Surrealist circle. Her work began to appear in Surrealist publications—in *Minotaure* (1937), in *Trajectoire du rêve* (1938), and in Breton and Paul Éluard's *Dictionnaire abrégé du surréalisme* (1938)—and her paintings were included in several international Surrealist exhibitions: London and Tokyo in 1937, Paris and Amsterdam in 1938, and Mexico City in 1940.

Following the German occupation of Paris, Varo and Péret, after many ordeals, made their way in early 1941 to the south of France, joining other artists and writers who had sought refuge in Marseille while awaiting exit visas from Europe. With the help of the journalist Varian Fry and the Emergency Rescue Committee, Varo and Péret were able to secure exit papers and passage to Mexico on the SS *Serpa Pinto*, the Portuguese ocean liner that would carry thousands of refugees across the Atlantic during World War II.[2] Unable

to pass through Spain to reach Lisbon, the port of departure, they first sailed to Oran, Algeria, and from there traveled to Casablanca, where in November 1941 they boarded the ship at its final stop before the Atlantic crossing.

It was an arduous voyage; as Varo recounted several years later in a letter to childhood friends, ". . . since the ship carried four times as many travelers as would normally fit, they packed us into the holds. . . . I couldn't bear it and grabbed my mat and went up to the deck, where I made the entire journey."[3] Upon their arrival in Veracruz in mid-December, Varo and Péret headed to Mexico City, a destination for other émigré artists and intellectuals, among them Wolfgang Paalen, Alice Rahon, César Moro, Esteban Francés, Gordon Onslow Ford, Emerico (Chiki) Weisz, Gerardo Lizarraga, José and Kati Horna, Leonora Carrington, and Eva Sulzer. With these last three friends, Varo deepened her knowledge of esoteric philosophies, alchemy, magic, and witchcraft—an engagement that greatly influenced her art, though she poked fun at these beliefs as well, as seen in her letters to Mr. Gardner and to "Monsieur," among other writings in this collection.[4] In 1947, Péret returned to France. Later that year, Varo moved to Maracay, Venezuela, where her older brother, Rodrigo, a doctor, had taken up a post in the Ministry of Public Health. It was during this sojourn in Venezuela that Varo created her arresting images for brochures commissioned by the pharmaceutical company Casa Bayer.[5] With the French pilot Jean Nicolle, she also traveled to the interior of Venezuela, around the Orinoco River, and "almost [took] a chance on crazy ventures with gold seekers."[6]

Eager to rejoin her friends, Varo returned to Mexico City in 1949 and would remain there for the rest of her life. Her last partner, Walter Gruen, a refugee from Austria who opened the city's premier classical-music store, the Sala Margolín, provided Varo with the support that allowed her to devote herself full time to her art from the early 1950s on. During this period Varo painted her most iconic works and began to enjoy artistic success, with two sold-out solo shows and a waiting list for commissions. Despite her growing

reputation, however, at the time of her early death—at age fifty-four, in 1963—few people outside Mexico City had heard of her. Had it not been for the efforts of Gruen, who survived her by more than forty years, to preserve her archive and assemble a catalogue raisonné of her work, Varo would probably never have achieved the widespread acclaim she enjoys today.[7]

Readers familiar with Remedios Varo as a visual artist will be delighted to find in these writings the same wit and inventiveness that she brings to her paintings. She draws on many of her favorite motifs: birds, goblets overflowing with water, aquatic voyages, ascending spirals, mathematical and scientific formulas, astral phenomena. Like her paintings, her writings are densely detailed, full of unexpected turns and playful in tone—though dark, too, at times.

The title piece, "On *Homo rodans*," is one of Varo's oddest creations. A spoof of scientific monographs, it asserts that a humanlike fossil, *Homo rodans*, discovered during an archaeological dig in the Carpathians, is that of a previously unknown predecessor to *Homo sapiens*. ("*Rodans*," a word invented by Varo, is a Latin-sounding variation of the Spanish verb *rodar*, "to roll, to move by means of a wheel.") The fictional male author, the outlandishly named anthropologist Hälikcio von Fuhrängschmidt—a nod to the "Alicia" and "Uranga" of Varo's own name—takes a long and digressive path (interspersed with salacious pseudo-Latin) before arriving at the *Homo rodans* itself, which is mentioned only once, toward the end. A model of pedantic exegesis à la Borges, one of Varo's favorite authors, "On *Homo rodans*," handwritten in the style of a medieval manuscript, was intended to accompany a small sculpture made of chicken, turkey, and fish vertebrae, crafted by the artist into a humanoid torso atop a large wheel (a photograph of it accompanies the text in this book). When Varo's sculpture was acquired in 1959, the unique manuscript went along with it into a private collection. Two years after her death, it would be the first of her writings to see print, in

a facsimile edition published by the small press Calli-Nova in 1965, followed by a reedition in 1970.[8]

If Varo has any renown as a writer, it is probably because of her letters. Leonora Carrington offers the best description of her friend's letter-writing practices in the novel *The Hearing Trumpet*, where Varo appears as the fictional character Carmella Velasquez, a redheaded Spaniard who "just happens to have a curious sense of humour," as the narrator, Marian Leatherby, observes. She goes on to explain:

> Carmella writes letters all over the world to people she has never met and signs them with all sorts of romantic names, never her own. Carmella despises anonymous letters, and of course they would be impractical as who could answer a letter with no name at all signed at the end? These wonderful letters fly off, in a celestial way, by airmail, in Carmella's delicate handwriting. No one ever replies.[9]

In this collection, Varo's playful "Dear Stranger" ("I've picked your name almost at random from the phone book") or "Dear Doctor Alberca" ("I signed the mysterious letters with the somewhat pretentious yet Machiavellian name of Gradiva") was perhaps in Carrington's mind as she described Carmella.

As we read Varo, we catch glimpses of her other friends: the photographer Eva Sulzer, the artist Wolfgang Paalen, Gerardo Lizarraga, her gallerist Juan Martín. Carrington, however, has the largest presence. In "Mistress Thrompston," the adventure-seeking, mackintosh-wearing journalist is a possible stand-in for Carrington. Another double, Ellen Ramsbottom, accompanies Varo's alter ego Felina Caprino-Mandrágora to the countryside for "days of meditation" in an exquisite corpse story of which we have only Varo's side.[10] In her humorous letter to Gerald Gardner, the British popularizer of Wicca, Varo introduces "Mrs. Carrington" as her accomplice in

exploring "the true practice of witchcraft" in remote parts of Mexico. In "A Part of A's Life," the unidentified X, whom A—Varo?—meets up with after the journey, "in that other city," could be Carrington. (They first became acquainted in Paris and later followed separate paths to "that other city," in Mexico.)

Would Varo have sought to publish for a wider audience if she had lived longer? As marvelous as her writing is, there is little reason to think she would have done so. As an artist, she was notably indifferent to public opinion. In a letter to Gerardo Lizarraga (included in this volume), she is explicit:

> It's very hard for me to understand the importance the recognition of your talent seems to have for you. I thought that for a creator the important thing is creating and that the fate of the work was a secondary issue, and that fame, admiration, people's curiosity, and so on, were inevitable consequences, more than things to be desired.

We can be thankful that those closest to Varo—Walter Gruen, her friends in Mexico, her family in Spain—saved her notebooks, letters, and stray papers so that her small body of writings could one day be read and enjoyed by a public she seems never to have envisioned. That a great artist should also turn out to be a gifted writer is indeed, as the title of one of her finest works has it, a revelation.

A NOTE ON THE NEW EDITION

The dozen or so notebooks in which Remedios Varo kept her writings were composition books intended for schoolchildren. A Spanish galleon on the high seas appears on one cover; another features an engraving of an

albatross, accompanied by a description of the species that carries over onto the back cover, where there's a multiplication table. The unprepossessing nature of these slender, faded notebooks gives no hint of the imaginative writings they contain—fantastic tales, Surrealist recipes, playful letters, automatic writing, and dream narratives—all in Varo's distinctive cursive script, alongside exquisite pencil sketches as well as everyday lists and expense accounts. Now housed at the Museo de Arte Moderno in Mexico City, the notebooks are part of a larger archive of the artist's personal papers, preparatory drawings, books, and other items preserved after her death by Walter Gruen, and donated in 2018 to the museum, the largest repository of Varo's artworks in the world.

Prior to the donation, most of Varo's writings had been published in Spanish in Isabel Castells's edition of *Cartas, sueños y otros textos* (1997)—the book on which my English translation in *Letters, Dreams & Other Writings* (2018) was directly based—and in Edith Mendoza Bolio's *A veces escribo como si trazase un boceto: Los escritos de Remedios Varo* (2010). On visiting the newly accessible archive to consult the artist's notebooks and papers, though, I made a few unexpected discoveries: several additional stories, a letter, numerous fragments, and a short poem by Varo—none of which had ever been published before, even in Spanish. *On* Homo rodans *and Other Writings* adds these archival finds to the existing translations of Varo's writings, now being brought back into print in the present collection.

Because Varo never prepared her writings for publication, assembling this book also involved work of an editorial nature. Much like Varo's artworks, her notebooks present mysteries: The writings, in pencil or in ink, alternate with drawings, often with long stretches of blank pages between entries. Some texts start at the back and work their way forward; others go sideways on the page. There is no particular order to the notebooks, and hardly anything they contain is dated. With few exceptions, the writings are untitled. Internal clues suggest that Varo most likely kept the notebooks

from the mid-1950s to the early 1960s.[11] Given the scarcity of erasures and crossings-out, and the regularity of her handwriting across the page, one wonders if the notebooks were a place for Varo to keep fair copies of texts she was especially pleased with or regarded as significant—for example, her letters to Mr. Gardner, Dr. Alberca, and others, the originals of which she presumably mailed. Other writings may be Varo's transcriptions of texts from an earlier period, such as the automatic writing, which she probably created in the 1940s after her arrival in Mexico with Benjamin Péret.[12] Uncertainties about the dates of most of Varo's writings, however, make a chronological organization highly speculative. For that reason, as her Spanish-language editors have done, I've arranged the texts by their affinities, gathering them into "Stories," "Letters," "Recipes and Advice," "Dream Narratives," and other groupings, with the title piece, "On *Homo rodans*," standing on its own.

Finally, a word about the editing of individual texts. Because *On* Homo rodans *and Other Writings* chiefly uses as its source text Varo's original, handwritten manuscripts, either in her notebooks or on loose pages, readers may find some variations if they wish to compare the translation with the Spanish-language editions of her writings. On reading Varo's handwritten stories, for example, one immediately notices that her sentences run long, with commas separating clauses that wind down the page and often on to the next, coming to a full stop only at the end of a long paragraph. For the sake of clarity and readability, I've lightly edited the writings, replacing some commas with periods but without entirely normalizing the punctuation.

Words and phrases underlined by Varo in her manuscripts are printed in italics. Phrases in the section "Images in Words" that were crossed out by Varo are represented here with a strike-through.

Editor's Notes at the end of the book identify people Varo mentions and offer additional background.

ACKNOWLEDGMENTS

Special thanks to Renata Villaseñor and Dolores Cobielles for their invaluable assistance in the Fondo Artístico Remedios Varo at the Museo de Arte Moderno, Mexico City; to Xabier Lizarraga Cruchaga and Tere Arcq for generously answering my questions about Remedios Varo; and to Marc Lowenthal and Judy Feldmann for their editorial support.

NOTES

1. A *cadavre exquis* from this series is in the permanent collection of the Museum of Modern Art: https://www.moma.org/collection/works/33175.

2. The website of the JDC Archives describes the journeys of the *Serpa Pinto* during 1941–1944 as follows: "The SS *Serpa Pinto*, a ship named after a Portuguese explorer and sailing under the Portuguese flag, became the leading bearer of refugees across the Atlantic during World War II. . . . Departing primarily from Lisbon, the SS *Serpa Pinto* made stops in Barcelona and Vigo in Spain, as well as in Casablanca, Morocco. It carried up to 800 passengers per sailing. The ship's destination was usually the United States, with other disembarkation points in Canada, Cuba, the Dominican Republic, Jamaica, and Mexico" (https://archives.jdc.org/the-ss-serpa-pinto-lists-a-resource-for-genealogy-research/).

3. Varo's account of the journey she and Péret took from Marseille to Casablanca and of the ocean crossing appears in a letter dated 5 February 1946 to the sisters Narcisa, Modesta, and María Martín Retortillo. Beatriz Varo, *Remedios Varo: En el centro del microcosmos* (Mexico: FCE, 1990), 216 (my translation).

4. For a comprehensive account of Varo's engagement with the teachings of George I. Gurdjieff and P. D. Ouspensky, see Tere Arcq's essay "The Esoteric Key: In Search of the Miraculous," trans. Michelle Suderman, in *Five Keys to the Secret World of Remedios Varo*, ed. Margarita de Orellana, trans. Lorna Scott Fox, Richard Moszka, and Quentin Pope (Mexico City: Artes de México, 2008), 20–86. Caitlin Haskell and Tere Arcq discuss Varo's interest in the magical arts, witchcraft, and esotericism in "Spirit, Matter, Story, Soul" in

Remedios Varo: Science Fictions (Chicago: Art Institute of Chicago, 2023), 17–27.

5. See Tere Arcq, "Remedios Varo and Her Work for Bayer," trans. Michelle Suderman, in *Five Keys*, 6–11. Beatriz Varo reproduces two letters Varo received in 1948 from the Mexican advertising agency Abastecedora de Impresos regarding her work on the Casa Bayer commissions. Varo, *Remedios Varo*, 221–223.

6. Juliana González, "Remedios Varo: The World Beyond," trans. Margaret Carson, *philoSOPHIA* 13, no. 1 (2023): 185.

7. For biographical information on Varo's life, I am greatly indebted to Janet Kaplan's superb biography, *Remedios Varo: Unexpected Journeys* (New York: Abbeville, 1988); to her niece Beatriz Varo's *Remedios Varo: En el centro del microcosmos*, and to *Remedios Varo: Science Fictions*, ed. Caitlin Haskell and Tere Arcq (Chicago: Art Institute of Chicago, 2023), especially the chronology compiled by Alivé Piliafo Santana, 150–165. Further information is in Ricardo Ovalle et al., *Remedios Varo: Catalogue Raisonné* (Mexico City: Ediciones Era, 2008). For additional background, I have relied on the initial chapters of Isabel Castells's *Cartas, sueños y otros textos* (Mexico City: Ediciones Era, 1997), Castells's updated *El tejido de los sueños* (Sevilla: Renacimiento, 2023), and Edith Mendoza Bolio's *A veces escribo como si trazase un boceto: Los escritos de Remedios Varo* (Madrid: Iberoamericana, 2010).

8. Remedios Varo [Hälikcio von Fuhrängschmidt], *De Homo Rodans* (Mexico: Calli Nova, 1970). There were 250 numbered copies in this edition.

9. Leonora Carrington, *The Hearing Trumpet* (New York: New York Review Books, 2020), 7.

10. In this collection, "Doña Milagra" and "It's Four in the Morning" are Varo's chapters in the narrative. Carrington's side has not yet come to light (see Castells, *Cartas, sueños y otros textos*, 52). A farcical play they coauthored, *El santo cuerpo grasoso*, is included in its entirety in Mendoza Bolio, *A veces . . .* , 233–295.

11. Several sketches can be related to paintings made during those years: *Tres destinos* (*Three Destinies*) (1956) and *Locomoción capilar* (*Hirsute Locomotion*) (1959). A list of gifts to bring to friends in Paris must have been prepared in advance of her visit there in 1958. "October 31, 1961" is the heading for the text "Huevo No. 5" ("Egg No. 5").

12. Biographer Janet Kaplan cites a sequence in Varo's automatic writing: "The mallows and turds, a forgotten hand, and those mysterious things floating, that tangle around the ankle at night. . . . All this and much more is boiling in

the vacant lot next door to the house." When Varo and Péret were living on Calle de Gabino Barreda, there was indeed a vacant lot next to their building, and Péret was surprised one day to discover there a human hand wrapped in newspaper. Janet Kaplan, *Unexpected Journeys*, 92.

On
Homo rodans
and Other Writings

Stories

"In a field in the state of Morelos"

In a field in the state of Morelos, where onions of the Glamour Gigantia variety are grown, alarm broke out among the campesinos who discovered, at sunrise, a gigantic animal in the middle of the onion field. On approaching to attempt to capture it, they saw it was none other than a mammoth, but motionless and as if petrified. This encouraged them to get even closer and then they discovered that it was an immense onion in the shape of a mammoth. They decided to examine its structure, and after peeling back no fewer than 4,316 onion layers, there appeared at the heart of the vegetable a small mammoth, alive and in perfect condition, 25 centimeters in size and weighing 1 kg. 100 grams. On pulling the gigantic onion from the ground a deep hole was created, and because some bones were glimpsed, an excavation followed which revealed the complete skeleton of a great mammoth. Nearly all the bones are engraved with signs and mathematical formulas, from the most simple starting at the tailbones, to the most daring and complex calculations known today, situated on the bones of the neck.

On the skull is a series of unknown signs and inside the mouth, well protected and wrapped in a pliable waterproof substance, was found a sort of book or ensemble of leather swatches sewn on one side. On each of the leaves is written the same enigmatic calculation, $2+2=0$. The mayor of the locale took charge of the small living mammoth (which is quite tame) in the hope that it will be accepted in the capital's zoo.

"Dear friend, I believe it's necessary to tell you of events"

Dear friend, I believe it's necessary to tell you of events that happened last Saturday so that you'll have a better idea of aeronautics and its psychobiological influence. Keep it secret for the time being, for otherwise we could be the victims of persecution by aviation companies that have until now managed to conceal events of this sort that occur all the time.

The thing began like this: Very early one morning, two well-dressed women arrived in a rush, clearly eager to set out on a journey. They seemed outwardly calm, but the taller woman was crisscrossed by tenuous streaks of a vivid saffron, and the shorter woman came along reciting a litany suitable for the occasion: "Yellow rebozo, yellow skirt, yellow and white blouse, Ye Mayab, may it please you propitiously to overlook my having, in my terrible agitation at getting up early, put on red shoes, I didn't do it to offend you, only because I didn't find any others and besides they're very old, Ye Mayab protect me . . ." Here the litany broke off because the poor thing realized with horror that she'd forgotten to bring along the Egyptian scarab and the royal eye, objects indispensable for a felicitous trip. Being a discreet person, she said nothing to her companion and boldly accepted a piece of gum when it was offered. Everyone boarded the fearsome object, which was incidentally blue and white and fairly narrow but full of hidden and explosive life. To make things clear, I must say that besides the two women,

a group of people with a shared sense of frivolity was also embarking on the same journey, all of them quite flawless in their choice of protective substances hidden in the depths of secret pockets, except for one stupid lady who covertly fondled a large, rusty nail, believing herself well protected by the iron, a substance, nonetheless, deadly to her person. I will insert a parenthesis regarding this because I don't want to pass over the inconceivable irresponsibility of aviation companies, which still have no procedures for screening passengers carefully enough to prevent their boarding in disastrous colors and with objects and substances inappropriate for their personal protection, with a possible, even fatal, interdependence in all of it. A specialist aided by a modern, superfine personality detector could do this very necessary work, which would prevent many inexplicable accidents.

I return to my story. Everything was in motion, everything was going well, the frightful clattering of thousands of tin cans cascading down the belly of an immense prehistoric animal that sighs in annoyance at the avalanche means nothing in particular, they're natural sounds, entirely natural, it's nothing, the woman dressed in yellow is contracting, and because she has good manners and, so as not to disturb her companion, she makes sure that this terrible contraction goes unnoticed and manages by sheer force of will to keep her skin from changing her exterior volume, but between her skin and the other elements of her body there is a gap of at least ten centimeters. The contraction increases still further, the separation between her skin and the rest is now fifteen centimeters, and she takes great care to make sure her volume remains the same. She cautiously turns her head and sees that everyone is calm and unconcerned, a man back there hastily conceals in his pocket a protective object, she saw it was something like an old bottle stopper

incrusted with black beans, and since the gesture of hiding the cork stopper was somewhat abrupt, he inadvertently bumped into the arm of his neighbor, who was squashed in such a way that you could see that this gentleman, too, though quite contracted, maintained his habitual volume, a sign of good manners. Both feigned not to have noticed this minor mishap. The rest, though seemingly unconcerned as I say, had decreased somewhat in volume, being weak-willed people. The woman in yellow verifies all this and also that, because of her ever-increasing contraction, an extremely tight, hard nucleus is forming in her middle, with tremendous irradiant properties of discomfort and affliction. It is essential to keep this nucleus from exploding, there must be some valve through which a bit of this distressing force can escape, for example, a short burst of laughter, the best would be barking, but that would be misunderstood. They're flying very low and she can count the trees, it's surely too low, on her arm a few brown hairs are unexpectedly sprouting, they're rather attractive but best to hide them just in case, but it's useless because more and more are sprouting, they're spreading all over, may they not come out on her face, she wraps her rebozo around her and without meaning to lets out a soft sound between a bark and a laugh. The nucleus seems looser after this, now she begins sprouting more hair, on her forehead on her cheeks, it's quite an agreeable sensation and is accompanied by joyful yelps, the contraction diminishes and she feels much better, her face is now covered in hair, her eyes gleam with enthusiasm, she lets out magnificent howls and the contraction has completely vanished, the rest of the passengers don't seem angry, they're affably playing canasta and they bark discreetly every now and then, the contagion has not been too severe, they've got only a few outgrowths of hair and don't seem concerned by it. They're passing a mountainside, so

close that the coyote who's always lurking there cannot resist the temptation and heeds the call that comes from the aircraft, with a delicate leap he mounts the wing and stations himself by the window, inside he beholds a magnificent sight, beside the window is a stupendous silky-haired creature who howls melodiously, at her side is a woman wearing red who, smiling benevolently, is trying to hide a beautiful tail of long fluffy hair that sprouted in the past five minutes and inconveniences her a great deal when she attempts to sit in comfort, and since she can do nothing to hide it she takes the comb from her purse and carefully combs this tail to make it look even better, the rest are howling jubilantly, they smooth the hair that on all of them is now much more abundant and they keep on playing canasta, the only difference being that they now hold the cards in their mouths.

The pilots open the door to have a look at the cabin, of course they're not pleased, on the one hand they're afraid of contagion, they decide to put in for a raise because of this constant risk that forces them, just to protect themselves, to consume only vegetables that have been planted, watered, and harvested during the full moon, on the other hand they also fear that these events, which occur so often, will become widely known, for it's already suspicious that such a quantity of hair must be swept from the cabins daily.

The coyote outside is very friendly, on their passing near a tree he takes up a vulture's nest and through the air vent offers several eggs to a man inside, who generously parcels them out; unfortunately, the last egg, which he was keeping for himself, already holds a chick, which hops onto his lap and grows quickly, the climate inside these conveyances being, as everyone knows, highly favorable to this type of bird, in a few minutes it's reached a good meter

in height and despite its having a shy disposition, its good nature and intelligence prompts it to begin a task of rapid depilation with its beak because they're nearing the coast now, and owing to the great hurry it leaves one of the passengers not only cleansed of hairs but also without eyebrows or lashes, now only the two most interesting women remain and the bird needs to speed things up because they're dizzyingly approaching their destination, on the other hand its development has become perilous, it's grown so much it takes up all the space intended for the passengers, who feel somewhat suffocated and poke out their heads through its feathers, the woman wearing red needs no depilation, her beautiful tail is reabsorbed all on its own, the other woman doesn't want to be depilated, she adores being able to howl freely and has almost reached a final agreement with the coyote to flee with him to the mountain, her friend understands that a quick and forceful decision is called for, she holds the woman down, the depilatory bird works furiously with its beak, now her face is clean, now her décolletage, the coyote is outraged, he bites hard into the side of the aircraft and through the hole a cirrus cloud enters and sows confusion, but no matter, they're landing now, they've just landed, a man's waiting there with a handsome mustache, as soon as the woman in yellow sees him all her superfluous hair instantly falls out, the vulture leaves discreetly through the hole and flies away, melancholy and satisfied, the women smile, the coyote leaped off some time ago and sits at the far edge of the airfield, looking at all those poor people and laughing his head off.

"One day when Maria was coming back from school"

One day when Maria was coming back from school, she saw Señora Blanca walking a few yards ahead of her. She liked her so much and wanted to catch up with her to look more closely at the beautiful white velvet of her clothing, but however she hastened her step, she couldn't get any closer. Señora Blanca was always the same distance away, without even seeming to try to go faster, instead she glided down the sidewalk like a feather pushed along by a light breeze. Suddenly she dropped a key, a large, golden key. Maria hurried to retrieve it and when she stood up she saw Señora Blanca turning down a small alleyway to her left, with only the hem of her white dress showing as it trailed around the corner. Maria ran after her to return the key, but on entering the alleyway she saw no one, she heard only the sound of a door closing. It seemed to her as well that a door halfway down the street had moved, she quickly went there, knocked and called out many times, but since no one opened the door to her, she decided to use the key. With great effort, she managed to open the door and immediately regretted having done so, the house was entirely empty and the whole floor was covered in dust, but in the dust could clearly be seen the tracks of a dove. This was quite enough for Maria's curiosity to grow so powerful that she lost all her fear and intrepidly followed the tracks down a seemingly endless corridor, in which there was not a single door. Only far, far away at the end light seemed to come from a door that was ajar. When she reached it she resolutely stepped inside.

She found herself in an enormous, windowless room. In the ceiling was an open skylight, through which she thought she saw a white splotch disappearing. On one wall a magnificent white velvet dress hung from a nail, she also saw a very handsome mirror and, at the back of the room, a table with a crystal chalice, from which came a sort of radiance. She approached the mirror to look at herself, wondering if she'd dare to try on the white dress, and stood amazed: instead of her image, a forest appeared in the mirror, and among the branches of the trees and on either side a great many birds were flying, and perched on the branch of the closest tree was a plump dove, which laughed merrily. For a while she amused herself watching what went on in the mirror, and afterward she approached the table somewhat warily. The chalice was very pretty and inside it was something that was glowing, it was a kind of seed but different from all the ones she knew. Near the chalice lay a letter and, unaccountably, the envelope was addressed to herself alone, there was not a doubt. Maria, who could already read quite well, took up the letter, opened it, and saw that it said "Take the chalice that holds the seed. Don't touch the seed, you could burn yourself. Go out, taking good care not to break the chalice, until you reach the great eucalyptus at the entrance to the forest. When you get there, wait."

She didn't hesitate a second and set out to follow the letter's instructions immediately. She took the chalice, left the house without a mishap, and, going through less frequented streets to avoid encounters, headed out to the countryside and was soon in the forest. She had been there many times but never very far inside, the forest was immense, no one knew where it ended. The great eucalyptus was nearby, and once there she waited. Before long she saw approaching a pleasant-looking young man, even though his

appearance wasn't exactly what Maria was accustomed to seeing in the young men of the city: he seemed like a combination of her classmate Pedro and her striped cat Pepito. Out of the pockets of his jacket now and then little mice emerged which ran along his shoulders and went to hide again in another pocket. This young man told her his name was Felix and that he had come for her on the order of the Señora, who was feeling rather tired.

Taking her by the hand, he led her quickly through the forest, they walked for a long time, Maria was exhausted by the time they reached their destination. Amid the trees was a house, rather small, but with a round, narrow and very tall tower at one corner.

They went inside. The entire interior of the house consisted of a large room in which hardly any empty space remained, for a great part of it was monopolized by the net somebody was knitting unceasingly. Maria coughed a bit to attract attention and at once a friendly white dove flew down from its roost and, after apologizing for not having stayed up to wait for her, it led her to the lady who was knitting. She merely raised her eyes, smiled, and went on knitting, after making a sign to the dove.

The dove then settled in comfortably and said to Maria: "This lady is Doña Eterna, I am her friend and companion, and, because of her great age, I serve as her spy and interpreter. She can no longer make herself understood to anyone, for she speaks another language, and nobody understands her nowadays. She's decided to take up residence here unconditionally but feels just miserable because of the total absence of birds in this place. She gets along famously with birds, who understand her and bring her news from all over, but now she gets bored and besides her knitting is nearly done, soon she'll have nothing to amuse her. I do what I can, but sometimes I'm exhausted by all the coming and going, fetching and

carrying news. This is why we need you, you must plant the seed you bring there, water it, and care for it until the tree that makes birds can sprout and grow, and then this forest will be as pleasant a place as she needs it to be.

"Once you have planted the seed, you must take the net, which will be finished by then, and go with it to the lake. There you will cast the net and whatever you catch will contain the liquid indispensable for watering the seed. Some of our friends from the forest can help you. Coming back from the lake you mustn't take the wrong path, for there is in the forest an old tree that is so ill-tempered it doesn't want to see any birds in the vicinity, because they seem to it dirty and noisy, and it can't stand the way they tickle when they perch on its branches. If you take the wrong path and pass nearby, it will try to rob you of the liquid we need so badly, do be careful. Now eat and rest, tomorrow you must begin."

Maria promised to do all of it faithfully, and after drinking a cup of honey she lay down to sleep.

The next day she carefully dug a hole where she placed the seed, marked the spot well, and, taking the net Doña Eterna had finished during the night, she headed to the lake. Felix and another amiable youth went with her. After reaching the lake and casting the net, they took from the water a pretty pot, tightly shut and sealed, within which was doubtless the precious liquid. They were so happy on their way back that they got distracted and took the wrong path, and a great misfortune was about to befall them, for the ill-tempered old tree was now reaching out an arm to snatch the pot. Fortunately, Don Ardiello caught on in time and could forestall the catastrophe by biting the tree hard on its arm and simultaneously tickling it with his tail.

Maria came back safe and sound and watered her seed, which in no time began to sprout. A few days later it was a friendly little tree, always good-humored and smiling, and in no time turned into a lovely vegetal machine that fabricated an infinity of birds. Doña Eterna was delighted, the dove put on some weight because it was getting enough rest, and Maria, her task completed, returned home. Her friends said goodbye at the edge of the forest and presented her with a pretty bouquet of flowers.

But Maria was left with the desire to return to the empty house on the alleyway to try on the white velvet dress. She surely went back and tried it on, but because it was rather large on her, she's thinking of returning once she's become a young lady.

"Mistress Thrompston discovers by accident"

Mistress Thrompston discovers by accident the source of the tremendous humidity that reigns in the County of Kent.

It happened the day she debuted a mackintosh of the latest style for travel and excursions. In fact, Mistress Thrompston was sailing aboard her mackintosh, musing upon an article she wanted to write for *WTrons – XVyl Magazine* (to which she is a contributor) in which she would scientifically analyze why some very dubious birds were born in the nest of the magpie with the best reputation among those that dwell on the roof of the Abbey.

This magpie had made off with all the Abbot's grandmother's rings and after transporting them to her nest and properly brooding them, those birds were hatched which, because of their sorry appearance, were refused admittance to the party that the Marquis of Ornitobello gave in commemoration of his daughter $\sqrt{Ax8}$'s fifteenth birthday.

This party took place in the city of Siena. The birds wore out their wings getting there and, on finding themselves turned away, raised a fuss at the British Embassy, but the ambassador himself bestowed upon them in person his best feather duster so that they could patch up their wings. That feather duster, which had several plumes from the hat of Admiral Nelson, was used to clean the dust from the Ambassador's collection of ancient Crospostmagnon coins.

But all this, which in reality is due to take place nine months from now and has already been written about in *WTrons – XVyl*

Magazine, which is dedicated to publishing only the future, was inexplicably reflected in a mirror Mistress Thrompston found in the grotto where she discovered the goblet full of heavy water that flows in perpetuity. The mirror is sixteenth century, without a doubt. The image became reflected in that era. There is no possible doubt about this, either, since Mistress Thrompston used the detector with a carbon 24 lens.

Given that, according to the calculations of the magazine's editor, the whole affair began with the birth of a magpie mistakenly hatched by a Welsh hen in the eighteenth century, it is inexplicable and confounding for that image to exist in the sixteenth-century mirror. Mistress Thrompston, by now very worried about the article on the mutation of the Abbot's grandmother's rings, set aside for the moment her plans for an article, but took extensive notes and interesting photos of a bronze plaque she saw on the wall of the same grotto, on which was engraved in Gothic lettering the recipe for paella valenciana. At the start of the recipe, three symbols can be perceived, mathematical looking but unknown. The recipe is signed and, though somewhat indistinct, the name Almz7X$\overline{\text{Vex}}$ can be made out. Beneath this there are several fingerprints impressed in the bronze when it had not yet hardened. Lower down one can see, crudely printed, three or four obscenities from a recent era.

Of course, all this was published nine months ago by the magazine, but Mistress Thrompston never rebels against destiny. She always does her duty scrupulously, and, as a result, will be decorated with the Cross of the Temporal Spiraloid as soon as she has recovered from the severe pneumonia she caught during her expedition, despite the good quality of the mackintosh.

The Knight Casildo Martín de Vilboa

The knight Casildo Martín de Vilboa was dubbed knight in the year of grace 1462 by His Majesty Amarraco IX, who thus rewarded him for his selfless and perilous crusade for the good of the Crown and the Holy Church.

Said knight had set to sea in a small, fragile schooner accompanied only by his secretary, the fearless damsel Dulcifís de Iruña, and three scoundrels, professional thieves, who had escaped on the eve of their hangings and hidden themselves in the bowels of the ship. The knight Martín de Vilboa was then a simple and modest man of science, a daring ornithologist, who had, for some time, suspected the existence of families of speaking owls in Iceland. Having been swept off by contrary winds, the schooner made land on torrid sands, where the young Casildo came upon a great multitude of speaking owls, though of a green exceedingly unusual for an owl. He seized, with the help of the damsel Dulcifís, a pair of said greenish owls and a good hundred eggs.

Fortunately, the three rogues who had hidden away in the schooner lay delirious and motionless, prey to violent fevers, so that the future knight could with ease distribute the eggs of the speaking owls over them and thus have them handily incubated. Seeing themselves so close to death, the three ailing men recited prayers during the whole voyage back, and the influence of these prayers was such that when the chicks hatched, an event that took place when the coast of the Basque lands was sighted, they were already

speaking fluently, reciting prayers unceasingly, which, of course, the pair of adult owls was doing as well.

The kingdom of Vilboa at that time found itself in a state of great dissipation and heresy and its inhabitants let as many as three and even four hours go by without saying any prayers at all. This state of affairs prevented the Sonorous Spiral of Prayer from reaching Heaven on a regular basis, provoking, for this reason, many atmospheric disturbances and storms. Nevertheless, once the great ornithologist had arrived with his praying owls and had distributed them throughout the region, a great Spiral once again ascended in a very regular way, and not only did the weather improve but the Vilboites, ashamed of themselves, followed the example of the birds and regained their high spiritual level.

This portrait was painted by the lay sister Rodriga de Varo y Antequera, who devoted herself to this Art, with the consent of her bishop and abbess, in the cloister of the convent where she lives in seclusion.

Letters

"My dearest sir, I have let a prudent amount of time go by"

My dearest sir,

I have let a prudent amount of time go by and now believe, or more, I am absolutely certain that your spirit will find it auspicious to be in contact with me. I am a reincarnation of a friend you had in other times. She was little graced, physically speaking: an abundant nose, freckled complexion, reddish hair, weight less than it should be. Fortunately, my present incarnation has kept as a physical trait only her reddish mane. The rest ... my friend! what a mango! Greek nose, seductive curves without being obese, the advantage of assets beyond compare, to make a long story short ... I have a few wrinkles? a minor detail! It is the equivalent of the noble patina that fine objects acquire.

This reincarnation was not easy. After my spirit had passed, first through the body of a cat, then through that of an unfamiliar creature belonging to the world of velocity, I mean the one that passes through us at over 300,000 kilometers per second (and which, therefore, we do not see), I went on to land, inexplicably, in the heart of a piece of quartz. Thanks to a dreadful storm, electrical phenomena favored me, and a lightning bolt, striking said piece of quartz, freed my spirit, which, having spiraled downward, lodged in the body of a voluptuous woman who was walking by. I feel pleased with this turn of events and that's why I dare to write you, in the understanding that you have not forgotten me.

I've considered the telephone an inhibitive apparatus, too cold for communication. But writing letters is different. I believe my residence in a piece of quartz is an experience that may interest you; other small discoveries, too. I am ready to tell all.

At first glance, this poem may seem obscure, but the simplest of electronic mechanisms, in use so often today, can break it into pieces and offer some clarity. If you feel inspired to answer me, do give me a detailed account of your current activity.

My own, over the past four months, has consisted of raising a supernatural puppy. He's a speaking, friendly animal, useful if there were great droughts because there flows from his body almost constantly an amber liquid that common people believe to be urine, but which I know is something of a superior chemical composition.

Because I live in a room with nonabsorbent flooring, I've decided that said animal should go live in Cuernavaca, in a garden where the plants can benefit from the moisture this creature yields.

Regarding the maniacal activity called Painting. . . . what can I tell you? We were both stricken by this disease, if you care to recall. I don't know if you've persisted in this odd form of perversion, I have, alas! and feel ever more ashamed of such great silliness.

Do you smoke? I've plunged into a colossal struggle against nicotine and against smoke in general. I've managed a partial

conquest of this matter and on good days smoke only six cigarettes. On days of longing, of depression, and when everything's a mess, well! then I don't know! This should be explained in a clear and precise way.

So then! of insomnia, of cold sweats, of liver-extract injections, of the desire to drill a rabbit hole into the earth to hide in, I say nothing! I await your news and only then will I tell you how I was visited, some while back, by a bewitching siren, a fervent admirer of yours who is very worried and unsettled because of your withdrawal from everyday life. A mystery!

I live, as before, in this pithead tower on Álvaro Obregón 72, telephone 11 20 84.

I remember the paellas of yesteryear, freedom of movement, and I kiss your phalanges, sir.

"What I'm reading now, Gerardo"

What I'm reading now, Gerardo, this—oh, how it hurts!—this let-
ter of loneliness, gloomy lamentations, it could have been
 was there a time?
Famous cantata.

 Provided we understand that Paris, London, Guanajuato,
Florence, Buenos Aires, Moscow, etc. will necessarily turn marvel-
ous or disastrous depending on your inner state. You can go from
here to there, but as long as you're not well, nothing around you
will be, either.

 It's very hard for me to understand the importance the rec-
ognition of your talent seems to have for you. I thought that for a
creator the important thing is creating and that the fate of the work
was a secondary issue, and that fame, admiration, people's curiosity,
and so on, were inevitable consequences, more than things to be
desired.

 The young Angela or Angelica (not sure which) who for
literary reasons goes by Nadine, I don't think she's the VIP you're
imagining, but it's only to be expected that Zeus (no less!) would
attempt to elevate her to his splendiferous state. There seems to be
some contradiction, however, because the pejorative term Peronelle
doesn't seem fair to me, either.

 In my view, she's no Peronelle (*loin de là*).

 I don't agree with what you say about Juliana. Everything she
did or undid, as crazy as it might seem to a biased observer, was

done as things should be done, that is, bravely and with no fear of the consequences. This way, everyone has the right to act as they please. But to jump into the water to swim and not want simultaneously to get your clothes wet, that, Gerardo, is impossible.

To this you would reply that if you had a lot of money, you could pay a woman a salary to take care of everything and that way there would be no consequences, I mean, right now your wife is serving as *femme de charge*, majordomo, *secrétaire*, wet nurse, etc. If you had enough money, of course! you could hire all that household help and there'd be no problem. But no matter what it was that Juliana did, it was done bravely, losing all or gaining all.

"O admirable and elusive goddesses!"

O admirable and elusive goddesses!

There have happened to me events of a singular nature: between alcoholic ones, musical ones, and vaudevillesque ones (excuse the Gallicism). The whole of it spiked with a strong element of the serialesque.

Though you live far removed from the worldly din, perhaps one of these days you'll consent to pay a visit to this humble hovel, where we will chat and drink water-chestnut juice and asparagus juice and perhaps admire some fairly good engravings I have depicting Bacchus, Noah, and some British colonel or other, now retired from service in the Indies. The contemplation of these engravings induces a certain state of intoxication, not alcoholic but instead hypnophotonic; specialists say it attacks not the liver but only the salivary glands and is harmless.

"Dear Stranger"

Dear Stranger,

I haven't a clue if you're a single man or the head of a household, if you're a shy introvert or a happy extrovert, but whatever the case, perhaps you're bored and want to plunge fearlessly into a group of strangers in hopes of hearing something that will interest or amuse you. What's more, the fact that you feel curiosity and even some discomfort is already an incentive, and so I'm proposing that you come and spend New Year's Eve at house no. . . . on . . . Street.

 I've picked your name almost at random from the phone book, I say almost because I looked for the page where those of your profession are to be found, I believe (perhaps mistakenly) that among them there's a greater chance of finding someone with a generous spirit and sense of humor. I should make clear that I'm not the owner of the house and that she is completely unaware of this gesture, which she'd probably call harebrained. I'm merely invited to go there, as are a handful of other people, so in order to attend you should call xxx–xxxx ahead of time and ask for Señora Elena, firmly declare that you've met before, that you're a friend of Edward's, and that, feeling lonely and blue, you'd like to go to her house to ring in the New Year. I'll be among the guests, and you'll have to guess which one of them is me. I believe this could be amusing. If you're a young man under thirty, it's probably better not to do anything. You'd probably get bored. While neither I nor the other guests are

elderly, we're not a bunch of crazy teenagers, either. Ah! Nor is this an escort service, instead, it's a psycho-humorous experiment, nothing more. I'm almost certain you won't go. One needs a lot of nerve to do it and very few people have that. You may also believe it's a case of a prank played by some friend of yours, or that this letter is a clever advertisement to lead people off to a dubious place, etc. etc. Nothing of the sort: the house is an exceedingly respectable bourgeois residence; I, and everyone else, mild-mannered members of the bourgeoisie who, nevertheless, as is happening to me at this very moment, may feel an irresistible impulse to make some adolescent-style mischief, in spite of my age and in spite of everything else.

I am going to copy this letter and send it to another stranger as well. Maybe one of you will show up. If both of you came, it would be something extraordinary and unheard of.

So, until soon, maybe . . .

On second thought, I believe I'm crazier than a loon. Do not dream that the living room will be traversed by an aurora borealis or by your grandmother's ectoplasm, nor will there be a shower of hams or anything in particular happening, and, just as I give you these assurances, I hope in turn that you're not a gangster or a drunk. We're nearly abstemious and halfway vegetarian.

"Dear Doctor Alberca"

Dear Doctor Alberca,

I've received a letter from my brother Rodrigo where he tells me that some photos of my paintings and the comments I've made about them interested you, also that you'd like to use several of them to include in a book you're preparing and in a lecture. Of course I have no problem with that, but I don't precisely remember the tone in which I made the comments, and I don't know whether, since it concerns something sent to my brother, they might be overly private. This wouldn't have the slightest importance if it weren't for the fact that all those paintings belong to different people who would feel outraged if they suddenly learned I've said: "This is the worst picture I've ever painted" or "What a shame I didn't decide to paint Doctor Chávez with the beautiful head of a falcon, just like his own!" etc., etc. I appeal to your good judgement to remove any sentence like that from my comments, which besides has nothing much to do with what is essential to the text.

My brother tells me you need these photos urgently, but I can't send them right away. At this time of year, because of the Christmas holidays, mad disturbances and upheaval are the rule. It would be impossible for me to get hold of the photos, and even if I had them (as is the case with some), it would be pointless to mail them because you'd never receive them. The post office here is an institution of irregular and capricious habits any time of year, but

during this one it turns into an infernal swarm of letters, packages, and cards flung into space in approximate directions, and you can't trust that they'll arrive in good condition or (if they indeed arrive) within a reasonable amount of time. So, if it's all right with you and wouldn't be too late, I'll send you a package of photos once these mix-ups and revelries are over, let's say around January 6th or 8th. Tell me, please, if you'll still be interested in them on that date. I wish you a Happy New Year and send you cordial greetings,

Remedios Varo

After writing the attached letter, which I regard as a model of simplicity and sobriety, I've added this page, which you should regard as written by my double. It's the first time I've written to a psychiatrist in an open and unmasked fashion, for I've already done so in a veiled and mysterious fashion three times, without getting any result. I wanted to test the waters before getting in touch with any of them, not so as to judge your wisdom or abilities, because I'm incapable of that, but instead your character as a human being. I believe that a psychiatrist should inspire above all affection and confidence. Ah! I'm forgetting to tell you that I'm interested in approaching a psychiatrist because I suffer enormously from a permanent sense of guilt, and since I haven't been able to improve anything on my own, I thought I needed someone's help.

I signed the mysterious letters with the somewhat pretentious yet Machiavellian name of Gradiva. Well, none of them answered! And that's how things were left.

It turns out I've kept the copy of one of the letters (the others were similar) and I enclose it. I was extremely surprised to receive

no answer, maybe people in your profession are overwhelmed daily by an avalanche of crazy documents.

Naturally, all this written by my double, you can calmly ignore it in the understanding that I know full well that you're extremely busy and that you probably don't have a lot of time to waste, but don't, just because I've dared to write you so boldly and freely, leave the matter of the photographs unanswered.

"Dear Mr. Gardner"

Dear Mr. Gardner,

I've just become acquainted with your book, which has aroused in me the greatest interest. A friend of mine, Mrs. Carrington, has been kind enough to translate it for me, since I'm unable to read or speak English.

I believe a correspondence with you or with one of the people in your circle (if you're too busy with your *recherches*) would be extremely interesting so as to exchange our experiences and knowledge with one another.

As you already know, in this country there is great activity in the realm of witchcraft, but all these usages are almost always restricted to the practice of medicine or to the manufacture of love potions, all in a fairly mechanical and somewhat distracted manner by the healer, and only because that's what the custom is. The main factor is always *the faith* of the patient, which in many cases brings about good results quite naturally. But this, doubtless of interest for psychology and psychiatry, is not what concerns us. In love potions, things are a bit more complicated and more dangerous because the custom is to administer "Toloache" concealed in a cup of coffee, and the effects of ingesting Toloache are deadly, the main one being a total loss of will. Leaving all this aside, then, we, I mean Mrs. Carrington and some other people, have devoted ourselves to searching for facts and information that are still preserved

in remote areas that participate in the true practice of witchcraft. Personally, I don't believe I'm endowed with any special powers, but instead with an ability to see relationships of cause and effect quickly, and this beyond the ordinary limits of common logic. Also, and after long years of experimentation, I am now able to organize in an optimal way the little solar systems in the home, I've understood the interdependence of objects and the necessity of placing them in a certain way to avoid catastrophes or of suddenly changing their placement to cause acts necessary for the common good. For instance, choosing my big leather armchair as the main celestial body, having around it and at a distance of fifty centimeters in east–west position a wooden table (originally, a carpenter's bench and strongly imbued with artisanal emotions), behind the armchair, at a distance of two and a half meters, the skull of a crocodile, to the left of the armchair, among other objects, a pipe inlaid with fake diamonds, and to the right, at a distance of three meters, a green earthenware pitcher, I have a solar system (I won't go into a detailed description of the whole, it would take too long), which I can move at will, knowing beforehand the effects I can generate, though at times the unpredictable is generated, provoked by the rapid trajectory of an unexpected meteor across my established order. The meteor is none other than my cat, but little by little I've been able to master this haphazard factor, since I've discovered that by feeding the cat nothing but sheep's milk his trajectory generates almost no effect.

Of course, my friends are also busy arranging in an optimal way little solar systems in their own homes, and we've established an interdependence among them. We sometimes swap celestial bodies from one home to another and of course, no changes are made unless we are all in agreement, because any other way, unpleasant

things sometimes occur. I should say that we've been able to achieve all of this thanks to a very long and in-depth study of mathematical variations and combinations, and by availing ourselves of one of our members' innate ability to group people and objects according to their true nature. The first step was the explosive revelation our friend had that his right shoe, a red velvet curtain, and a snippet of opera (audible at that moment) were exactly equivalent. From then on everything was easy since, condensing things into large groups, the mathematical operations on variations and combinations are quickly done.

Now I'd like to ask your advice about something. This land we live on is highly volcanic (as you probably already know). A member of our group finds himself in a very difficult situation because of the volcanic tremors in the subsoil. A person of limited means, he lives in a terribly old house that lacks any comforts, though it has the advantage on the other hand of a lot of space and a fairly ample inner courtyard. This house is situated in a very central area of the city. Some months ago, a little mound began to rise on its own in the courtyard. Out of the mound a wisp of smoke and an intense heat began to emerge, after that, at longish intervals, small amounts of something that we immediately saw, with horror, was lava. There's no room for doubt, it's a small volcano that perhaps at any moment could turn into a tremendous threat. Our friend, who doesn't have the means to look for other housing, wants this to be kept secret, since otherwise he'd be turned out of his house, which would please the owner, who, with the volcano as an excuse, would construct in its place a grand building complete with central heating.

Well then, we immediately saw the chance to do some experiments on this manifestation of Nature. We quickly built some walls

around the volcano and a roof to conceal it from the eyes of the neighborhood. Currently, the enclosure is used as a kitchen. The little mound's height allows you to cook over the crater easily, and I must say that it's admirable at preparing shish kebabs and brochettes to perfection. But we're getting away from the advice I wanted to ask you for. Despite our nonstop work, the numerous experiments etc., etc., we have been entirely unable to include in our solar systems the substances expelled by the volcano, or to use them, either, in our practices in any way, fresh lava is totally rebellious and to all appearances acts independently. The only outcome to date has been a severe allergy attack suffered by Mrs. Carrington, who applied a certain quantity to her scalp. Perhaps you're acquainted with the possibilities of this substance and how to harness the energy it contains. In my view, since it comes from depths not permeated by our emotions and belongs to a denser world of mineral emotions, it presently escapes our understanding, but I passionately desire to understand it in order to, if possible, help it on its flight toward a less dense world, and also to get it to understand and enter into our purposes as well. I beg you to tell me whatever you know about this material as soon as possible, since the volcano hasn't grown more than a centimeter a week, but we cannot know what will happen in the coming months.

I'm afraid my letter may be too long, and though I'd like to talk to you of other things, especially the conviction we share about the possibility of destroying the pernicious effects of the hydrogen bomb by means of certain practices, I'll leave the discussion of all that for another occasion, if you would be kind enough to answer me.

"Monsieur"

Monsieur,

I take the liberty of writing to you and beg your pardon for my presumptuousness, and likewise for my bad French, but I find myself gravely distressed and don't dare confide to any of the people in my circle that I've been suffering from certain disturbances, about which I believe you can advise me.

The thing began about six months ago. With great enthusiasm I was painting a canvas in which you could see a pleasant meadow, with cows and sheep serenely meandering around. I confess I felt satisfied with my painting, but lo and behold! little by little an irresistible force compelled me to paint, on the back of each sheep, a small flight of stairs, at whose highest end was an image of the woman who lives across from me, and on the cows I felt obligated to place, with anguish and in haste, some well-folded handkerchiefs. You can imagine my surprise and dismay. I hid these paintings and began others, but I always found myself compelled to introduce strange elements into them, until a moment arrived when, having accidentally spilled a fair amount of tomato sauce on my trousers, I found the stain so extremely meaningful and affecting that I quickly cut the piece of fabric out and framed it. I've felt obligated, ever since painting the first canvas I mentioned to you, to lead a near-clandestine life, afraid that my people, finding me out, would have me examined by a psychiatrist.

Shortly before these pictorial phenomena took place, I had set about rearranging the solar system on my table, a task that must be carried out every 210 days, since this activity is obligatory for all the adepts of "The Observers of the Interdependence of Household Objects and of Their Influence Over Everyday Life." This group, active for quite a long time now, has already made important verifications that make life easier from a practical point of view, for example, I move a can of green paint some five centimeters to the right, I stick in a thumbtack next to a comb and if Mr. A. . . (another adept who works in tandem with me) at that same moment places his book on beekeeping next to the pattern for cutting out vests, I'm sure that there will come about, on Avenida Madero, the encounter with a woman who interests me and whose origin I've been unable to determine up to now, or her address, either. We've achieved some small triumphs over everyday life, as you can tell. I won't cite any more examples for fear of boring you, but I could give you a broader vision of our group's activities if you happen to be interested. For now, please know that my ancestors didn't invent the wheel for utilitarian purposes (they used it only for children's toys) and not because of a lack of beasts of burden, because slaves and prisoners of war could have served such a purpose very well, but because their intelligence had developed in an entirely different direction. Of their KNOWLEDGE, some conquests have been kept in the strictest secrecy, operations that reduced to zero the infinity of mathematical variations and combinations. In a relatively short time, one can establish, by means of these operations, myriad cause-and-effect relationships by combining and varying the object-elements.

But coming back to my own case, on manipulating an old telephone book, a sprig of rosemary, a thumbtack, a comb, a can of

green paint, a woman's shoe of pearl-embroidered violet velvet, and a counterfeit five-peso coin (this group of objects is my universe of instruments, whose operation is in agreement with and interdependent on that of the other members of the group), I permitted myself to add, a short time ago, as a novelty, a dried hummingbird stuffed with magnetic dust, all of it well tied with cord, just as mummies are wrapped, using red silk thread. I did so without warning my colleagues, a very serious transgression according to the regulations of the group. Only our leader, with his long experience and his high degree of knowledge, can do something like that without bringing on grave consequences, what's more, I intentionally put the can of green paint under a beam of red light that was coming through the stained-glass pane of my window (a complementary horror!). I did all this without weighing the consequences (having become an adept a short time ago, my control reaches only the objects I mentioned earlier). As was to be foreseen, certain incidents have come to pass since the day of my transgression: my best shirt got scorched, a large salt deposit has piled up under my bed, and the very next day brought the onset of the surprising transformation of my painting. Now I wonder, is all this a result of my ambition to introduce new elements into my solar system? Is it a sudden folly of my subconscious that, in an attempt at freedom, has impelled me to paint in a different way and to act chaotically concerning the very important elements that make up my practical-domestic universe? Or am I simply mad . . . ?

My usual occupations are selling perfumes of a French brand, which I represent, and I'm also the manager of an herbal apothecary. As far as painting goes, I'm only a Sunday painter.

Recently I had the good fortune to read certain Surrealist publications that were of great help and reassurance to me. This has

made me decide to write you, to ask for your opinion on my course of action, along with your advice on what books I should read to enlighten myself about it.

I hope I've aroused your interest in my case. A response from you would be the food my spirit craves most.

<div align="right">Fernando González</div>

My address:
Fernando González
c/o Emile Zubrin
San Ángel

To the incomparable Doña Rosa de los Aldabes

My dear Madam,

No doubt you have been advised of the troubles that have befallen me on account of belonging to the species named *Homo sapiens*. I have come to understand that in this mammalian class, all the most voluminously fleshy parts are, so to speak, suspended from what we call the vertebral column. This is a kind of tariff paid to Nature for the fact of walking on two legs. I wouldn't dare take up going on all fours again and in that way distributing the weight of my body in a less dangerous manner, it isn't that I don't want to because of aristocratic prejudices, but instead because it would force me to buy a whole new wardrobe adapted to the circumstance of going on all fours, not to mention that my packs of felines could feel disconcerted and distrustful.

Things being as they are, my dear friend, I find it necessary to shore up said vertebroid column, whether from within or from without. At present I have chosen external bracing, for the internal kind requires the finest of osseous carpentry work. I would like to ask you if among your contacts there isn't someone who might know an accomplished corsetiere who could make, according to my instructions, the exact type of corset I urgently need. Having already attempted to have one made in the atelier of a Neanderthal man, I got the double of the corset used by the wife of a Crusader while he was away in the Holy Land, but since customs have now changed and the capacity to wear a certain type of harness is less

with respect to delicate feminine structures, I would like to have a more bearable harness made.

I have learned by way of Don Gerónimo Wagram de los Vascos that you have abandoned your rather ancient castle on the Avenida de Veracruz in order to move into a modern little palace on the gentle plains near the great gullet of the Reforma. I hope to be able to visit you one day and I will bring you one of those wild boar pies that my slave Totonacarada seasons with such great care.

And in closing, I would like to ask you if Your Excellency has had a free moment to place your nimble fingers on my knitted apparel, now that the winter cold and snows are deepening, and whether you have been able to solve the lack of raw material that (according to the young scions of Don Gerónimo Wagram de los Vascos) has arisen.

Perhaps it is too daring of me, but I would like to see you in this your humble cavern, some day that is not a Monday or Friday, as on those days I have to meet with a specialized Teutonic amazon who applies radar and supersonic waves to the part of my body where we ought to have had a beautiful, fluffy angora tail had Nature not been somewhat parsimonious with us, it would moreover have greatly advanced the art of hairdressing and the use of plastic rollers and bobby pins.

Without further ado and anticipating your eagerly awaited news, I remain here to tend to and monitor the so-called "Fifth lumbar," an osseous structure to which I advise you to pay close attention and afford the greatest possible repose.

My respectful greetings to your entourage and as ever, admiring the unique blue of your eyes, I take my leave, languorously fatigued.

<div align="right">Remedios</div>

"Mexico City, 11 November 1959. Dear Friend"

Mexico City, 11 November 1959

Dear Friend:

Your letter arrived this morning with the check, and I'll inform you right away of this happy development.

We now have permission to export the painting, and as soon as the packing crate is finished, we'll ship it to you by air. The crate will be very sturdy, we've ordered it from a trusted carpenter.

I thank you for the kind interest you've taken in my health. My fifth lumbar vertebra proved to be very rebellious and painful. This kept me from painting, but I've put it to use to write some well-documented anthropological notes, for I have long been wanting to point out the fact, unknown until now, that the predecessor of the *Homo sapiens* is the *Homo rodans*. I don't know if you'll be interested in reading these notes, but in case you are, because it's a matter of only a few pages, I'll have them translated and send them to you. In any case, I'll send you a photo of *Homo rodans*, which might interest you, since you are a man of science.

Before I go on, I'd like to forewarn you that, if you find a word you don't understand in one of my letters, it's useless to look it up in a dictionary, since my spelling is, regrettably, totally different from what's admitted in common dictionaries, alas!

You wanted some biographical information about me. I was born in Spain, studied painting at the School of Fine Arts in Madrid, went to live in Paris and was part of the Surrealist group there; after that, I settled here, where the climate is much better from any point of view. I'm going to look for articles and newspaper clippings that talk about my paintings and will send them to you.

As soon as we stow the painting on the plane, I'll write you so you'll know that it's been sent.

If you engage in experimenting with chemicals, I hope that what happened to me won't happen to you. I believe I can tell you what happened, I was experimenting to find a product that, strange as it seems, was neither an elixir for eternal youth nor a means of turning all the solids around me into gold. I wanted to find a substance that would soften and reduce to an imperceptible film the skin of peaches, a fruit I like a lot but which upsets my stomach because of the skin. Since I was convinced that great discoveries are perhaps the result of chance (objective chance), though one in which objectivity cannot intervene in the mathematical variations and combinations that establish a cause-and-effect relationship, I experimented with various substances. At the same time, I played certain special and individual notes on a monochord. If I am right, this sound could have a decisive and transcendental importance on the substances I was attempting to combine.

Suddenly, something terrible happened. At the moment that I was playing the note B, and just as I was about to go on to another octave in a slightly more serious tone, the cat meowed and someone passing in the street in front of the window cast his shadow on the laboratory table and on the substances I had in emulsion there. These substances separated, leaving a minuscule, brilliant particle,

a kind of pearl that went out the window like an arrow, rose into space and rapidly disappeared from view. But what's terrible is that it left behind it, permanently, a thread of earthly atmosphere.

This particle of substance, insusceptible to gravity, was, fortunately, very small, and after carrying out several mathematical calculations, I've come to the conclusion that the Earth will not lose its atmosphere before 62 years is up. Obviously, we have no reason to worry personally, but we ought to think of our nieces and nephews and descendants. This is what impels me to search for the way to put a cap on this dangerous opening in our atmosphere.

Although I've assembled the same elements, have put them in exactly the same place on the table, have done so on the same date of the year, and have played B on the same monochord (that is to say, in the tone necessary for the new gravity-free pearl not to drift too far but to stop right at the edge of the atmosphere like a cap) and though my cat has meowed in the same way and all the members of my family have paraded before the window casting their shadow, in spite of everything, the experiment has not worked. I know quite well that the shadow should be of the same person who passed by back then. But who is it? I've searched all over, it was a man and he was wrapped in a black velvet cape, but I haven't been able to find him, I've traveled, I've asked questions, I've rendezvoused with various men under my window, but none of them was him. What am I to do? Please advise me. All this happened three years ago now; we have, therefore, 59 years of atmosphere left.

I beg you to write and tell me if you've been able to read my execrable French, also tell me your opinion of *Homo rodans*. A cordial greeting from

Remedios Varo

On Homo rodans

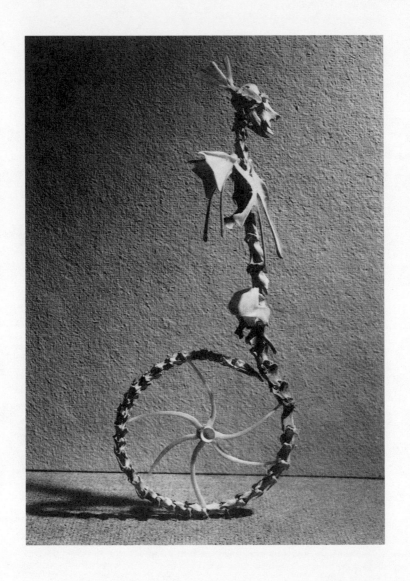

After reading the treatise on lumbar vertebræ coming from the erudite pen of the renowned anthropologist W. H. Strudlees, which was disseminated by the Viennese Anthropologists Guild, and after confirming the harm it has done and the great confusion it adds to that which already exists, I have decided to write up the following notes.

I have no qualms about branding said treatise as lewd and inaccurate, and I don't know which distresses me more: its osseous-historical inaccuracy or the refined lewdness it exudes. Before turning to the matter at hand, allow me to remind you of those words pronounced by the wise and venerable Cardinal Avelino di Portocarriere at the famous Council of Melusia: "... *et de fragmentus oseus lumbaris non verbalem non pensarem, conditionæ humanitas Luciférica est. Et de pensarem ou parlarem lumbarismus pericoloso et cogitandum est ...*"

Without a doubt, this rather austere point of view is not of our time, for we are accustomed to such things as tibia, fibula, and even femur being mentioned without circumlocutions. But I would like to see Latin or Greek terms used to name other osseous structures situated in the region of the human body in which "... *pericoloso et cogitandum est.*"

And now let us turn to the osseous-historical analysis of the present-day anthropological situation that gives rise to the appearance of writings such as that of Mr. W. H. Strudlees.

In the first place, I believe it only proper to remind readers that the majority of what are considered great discoveries, anthropologically speaking, have been made when current erroneous ideas about Myths are set aside and they recover their true meaning of Myrtles.

During antiquity, Myths were short fables that Babylonian wet nurses were in the habit of telling children. None of them have come down to us.

Myrtle was the name given to the recounting of phenomenal events that were empirically verified and transmitted, either in written form or orally. They took the name Myrtle because of the heavy consumption of this plant during intellectual gatherings and ceremonies. The corruption of the word Myrtle took place in the year 850 BC when the wise and erudite Abencifar ebn el Mull (whose treatise "Necrophilic Myrtleology" is a model of scientific objectivity) pronounced his famous discourse on the ancient Myrtle called "On the Uses of Amber in the Villages of Tulzur." The venerable Abencifar ebn el Mull was suffering from a severe head cold and laryngitis and, on beginning his address, "and this myrtle of which I am going to speak so as to propagate and promote the post-trepanatory use of amber in its elastic, pre-solid state . . . ," his voice was unclear and several scribes, who had come from Calcarea to take down his words, misunderstood and recorded the word Myth instead of Myrtle; since then, a great confusion has existed, since some oral reports as to the meaning of "Myth" have continued to spread, but without fully clarifying its limited and particular use among Babylonian wet nurses.

To return to my analysis of the situation, I believe it urgent to establish once and for all that the word "evolution," with its content of erroneous ideas about the possible movement of things in a way

that is mechanically devoid of transcendental will, is the source of the prevailing ignorance and confusion. Just as the great Algecifaro, whose words we know by way of Tivius Tercius, used to say: "... *et ainsi evolutionæ irreparabile esjundem confusionæ per secula seculorum est.*" There is no doubt that our known Universe is divided into two clear tendencies: that which tends to harden and that which tends to soften. This is the present situation.

The First Attitude is the unanimous preference for hardening. After pitched battles, the great masses of connective tissue separated into pieces of varying hardness, and the most ambitious parts persevered in their endeavor until they saw, with alarm, that the advisable limit had been exceeded calamitously. These groups, today mistakenly called inorganic matter, now have a constant tendency to soften, while the other part would seem to tend toward hardening. Hardening gains in prestige daily: hard muscles, inflexible character, exercises aimed at hardening feminine anatomical surfaces and volumes, etc. This tendency toward hardening was already notable in the age of Quintilian, who tells us in his Torrid Narrations: "... *et procer venerabile et vetustus caminandum naturæ vislumbratun virgo impúdica virgo tórbida et ornata duobus globis durissimos et homo vetustus appetitum venere ardencens luxuria et sudore suæ atque recondidit membra simulacris voluptatem consumatum est.*"

The unanimous tendency toward hardening (better than tendency, the yearning, I would say) that reigned during the First Attitude or the First Movement, as Jean François de la Croupiette so rightly calls it, what is it but the irrepressible desire to transcend that animates each and every thing? A perhaps unconscious and disorderly desire, but no less tenacious and dangerous on that account since we have many examples of the terrible results of the

transcendental softening of the mineral depths when they began to retreat from their misguided and audacious route toward absolute hardness. From the eruption of Moolookao in central Africa until our days, how many ruins and disasters! Pompeii, Herculaneum, Parfis, Moscolawia, Bois-Colombes, El Pedregal, etc., etc.

To illustrate this transcendent yearning, I wish to remind you of that singular discovery made at the excavations of Lilibia in Mesopotamia, when, after unearthing from a depth of twenty-five meters the famous ark carved in hypogenic rock containing the clay tablets of Queen Tol's cuneiform diary, excavation resumed and an umbrella appeared, two meters beneath where the ark had been.

This object, currently in the British Museum, resulted in great controversies, and a total of thirty-two essays have been written in an attempt to clarify its origin and nature. All of them are misguided. Some of them claim that it is not an umbrella, but rather a wing, fairly complete and quite well-preserved, of a young pterodactyl; the others affirm that it is an ordinary umbrella, dragged there by a subterranean slippage of argillaceous soils.

The fact that the object was found surrounded by carbon $1/3\ 35^3$ and by no fewer than fifty lumbar vertebræ, all belonging to the same individual, is not even mentioned. I believe the moment has come to mention it.

As we are very well aware, carbon $1/3\ 35^3$ is extremely scarce and can only be found among the Mesopotamian post-troglodytic strata. The era of carbon $1/3\ 35^3$ corresponds exactly to the beginnings of the use of the cane. It is natural that man, when he decided to walk on two extremities, would help himself at the outset with canes. These canes were so important that their dark transcendental yearnings gradually materialized, since they constituted a third

locomotive member, but when their use was suddenly abandoned, the majority, seized by a violent frustration, were left petrified. Some, with a stronger transcendental capacity, abandoned the leg as model and goal, and quickly found other ideals for movement and locomotion.

The powerful wings of the pterodactyl were the goal of many canes, and such was the case for the cane-turned-umbrella discovered in Mesopotamia, which in truth was nothing but that. The fact of its having gone on transcending beyond the pterodactyl and of having become the First Umbrella gave rise to the confusion and discord in the group of anthropologists who made a close study of this object.

The transcendence of canes is faithfully related in the fifth book of the Cadenced Multimyrtle, a collection of poems and canticles from the year 2300 BC, coming from an anonymous Persian and preserved in the collection of palimpsests in the palace of Prince Odelfo di Malspartini in Mantua.

As is common in our day, that whole grouping of historical poems and scientific canticles is considered merely a curiosity for bibliophiles, and not a useful reference book.

If Mr. W. H. Strudlees would take the trouble to consult the Cadenced Multimyrtle, he would immediately know the truth concerning the inexplicable abundance of lumbar vertebræ, belonging to a single individual, that were discovered on the southern slope of the Carpathians and about which the same silence was not maintained as about those discovered beneath the ark of Queen Tol.

Such vertebræ are indisputably human, and for that reason serious thought is being given to the need to consider the existence of a *Homo reptans* preceding *Homo sapiens*, which would be a profound error.

Homo reptans never existed, but *Homo rodans* did indeed exist, and we can find its detailed description in the Multimyrtle, and not only its description but also a drawing so precise that I limit myself to reproducing it.

I hope this clarifies once and for all the murky anthropological situation created by Mr. Strudlees, as well as the lewd presumption of aphrodisiac reptality with procreative intent.

But even though I believe I have achieved my principal purpose, I hesitate to end before warning of the expedition led by Mr. Frederik Zathergille, who is on his way to the region of Eritrarquia to carry out excavations, about which I advise infinite caution and a high degree of mistrust.

In an era well before the Cadenced Multimyrtle, the high society of Eritrarquia became exceedingly interested in anthropological excavations, this taste becoming a sport or game to which they frequently devoted themselves. As they had no desire to do strenuous exercise or to dirty their sumptuous attire, an ingenious industry soon sprang up that consisted in training a certain breed of especially intelligent moles, who were taught to tunnel rapidly until they found some object, bone, or pottery shard that, once discovered, they would bring back in their teeth.

In the countryside near Eritrarquia, various mole trainers had set up shop with cages suitable for these animals. City sophisticates would rent one or two moles along with a wand made of almond wood that, before the mole was released, would be used to detect, as dowsers do, the place where said shards were to be found buried.

Soon there was so much competition among the different cage owners and archaeological terrains that several of them, at night and with great caution, set about burying all sorts of bones, pottery, and objects they had brought back as contraband from the

faraway regions of Mulm, which would make their clients more numerous and their terrain more esteemed. Without a doubt, many of these objects have remained buried there, and today's anthropologists and archaeologists must take utmost care on classifying their discoveries.

And I conclude by reminding everyone that we are at the threshold of the Second Movement: the soft and elastic will harden, the stony and rigid will soften. Let us hope that on reaching the perilous, crucial, unifying moment, each of these tendencies will ricochet off the wall of time and turn back, since if not they will cross in space and after an era of painful confusion in which all matter will be Hybrid-Maniacal Infernaline, the one will come to occupy the place that the other held before.

I trust that the prophecy of the enlightened Augurusthus will be fulfilled: "... *et de materiæ petreus, nefanda et scabrosissima trascendentia producerese, et de tiernam elastiqua materiæ movimento petrificatore adrivate. Tempora murallis separatum duos et rebotandum majestaticamentæ con fungoide luminaria, petreus materiæ et elastiqua substanciæ, ocuparem suos lugarem naturalis ad majorem comprensionibus mutua per milenariæ tempora...*"

<div align="right">Hälikcio von Fuhrängschmidt</div>

Recipes and Advice

Algecifaro ben el Abed
RECIPES AND ADVICE FOR DRIVING OFF INOPPORTUNE
DREAMS, INSOMNIA, AND DESERTS OF QUICKSAND
UNDERNEATH THE BED
Translated from the Arabic
by Felina Caprino-Mandrágora

Allah is Allah and Mohammad is his prophet
However . . .
 It's very disagreeable to spend the whole night running, chased
by a lion, to arrive, at last! before a door, to seek refuge behind it
and to discover that there's a deep well into which we'd long to fall
(into placental-maternal arms, of course) but into which we do
not fall, we fly over it and come to an enormous room with many
doors and behind each of them is the same lion, the only escape
is to climb up the cut-glass chandelier, but it's impossible because
from the very same chandelier the postman is coming down with
a telegram announcing the birth of four Mauritanian twins in the
kitchen . . . etc., etc. you already know what comes next!
 To avoid such contretemps, it's best to follow the simple and
healthful advice we provide below:

TO PROVOKE EROTIC DREAMS

Ingredients
1 kilo horseradish
3 white hens
1 head garlic
4 kilos honey
1 mirror
2 calf's livers
1 brick
2 clothespins
1 whalebone corset
2 false mustaches
Hats to taste

Pluck hens, carefully reserving the feathers.

Set hens to boil in two liters distilled water or rainwater, without any salt and with the head of garlic, peeled and mashed.

Let it boil on low heat.

While the fowl are boiling, place the bed pointing northwest to southeast and let rest with the window open. After one half hour, close window and place red brick under the left-hand leg at the head of the bed, which must face northwest. Let rest.

While the bed is resting, grate horseradish directly over the broth, taking care that your hands are constantly steeped in the steam.

Stir and let boil.

Take the four kilos of honey and with a spatula spread on the bedsheets.

Take the hens' feathers and scatter them over the honey-smeared sheets.

Make bed with care.

It is not essential for the feathers to be white, colored ones can be used as well, but so-called guinea hens must be avoided, for these at times bring on a state of nymphomania of varying length or severe cases of priapism.

Put on corset and lace tightly.

Sit in front of mirror, calm your nerves, smile, try on mustaches and hats according to your tastes (Napoleonic tricorne, cardinal's galero, lace coif, Basque beret, etc.).

Put the two clothespins on a saucer and place beside the bed.

Warm the calf's livers in a bain-marie taking great care they don't come to a boil, place the warm livers in lieu of the pillow (in cases of masochism) or on both sides of the bed within hand's reach (in cases of sadism).

From that moment on, everything must be done at high speed to prevent the livers from cooling off.

Run and quickly pour the broth (which must be very reduced) into a cup. Return with it in a hurry to the mirror, smile, take a sip of broth, try on a mustache, take another sip, try on a hat, drink, try on everything, take little sips between one trying-on and the next and do all of it as quickly as you can.

Once the broth is consumed, run to the bed, lie down between the prepared sheets, rapidly take up the clothespins and insert into each of them your big toe. These clothespins must remain on all night long and be placed at a 45-degree angle to the toe, pressing firmly on the nail.

This simple recipe always gives good results and ordinary people can pleasurably go from kiss to strangulation, from rape to incest, etc., etc.

Recipes for more complicated cases such as necrophilia, autophagy, tauromachy, Alpinism, and others are to be found in a special volume from our collection: "Discreetly Healthful Advice."

Ingredients
One dozen ram's legs
20 eggs
40 bricks
3½ meters of raw silk
A large, soft sable-hair brush

Take ram's legs, which should be clean and stripped of wool. (The wool should be set aside on a small plate.)

Bring to a boil on a wood fire, in an empty barrel that has held plum aguardiente.

Separate egg whites and yolks, taking great care not to break the yolks.

Place the latter on a piece of crêpe paper some two and a half meters long, making a regular pattern. Let stand until the yolks stick firmly to the paper. This paper will be used as a blanket.

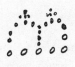

Once the ram's legs have simmered to the point of yielding a hearty broth, throw them out the window in the direction of Alpha Centauri.

Let broth cool.

Take the 40 bricks and place ten of them under each leg of the bed.

Lay out the 3½ meters of raw silk like a bedsheet, on top of it the crêpe paper with the 20 egg yolks.

Beat the egg whites with a wooden fork and let stand.

At this point take off all your clothes and get into the barrel containing the broth. The bath should last for some three-quarters of an hour.

When getting out of the barrel do not dry yourself with a canvas, but instead do Swedish calisthenics for half an hour and let your body dry by means of the heat generated during the calisthenics.

Once dry, take the sable brush and, dipping it into the egg whites, begin to paint your body, starting with the feet. A long-handled brush is advised so as to reach your back and other posterior places.

When your entire body is coated with egg whites — — — — —

The $\mathcal{E}\sqrt{-1\pi}$ Library informs the public that its department of conservation and study of books and documents relating to the customs and habits of the twentieth and twenty-first centuries is not responsible for the condition of the present volume.

The ferocious and bloody wars unleashed at the end of the twentieth century were not caused by political differences, but instead by the possession of this book. The recipes and advice that it contains, once practiced by the majority of the inhabitants of the Empire of Gibraltar, brought the empire to the apex of power, an intolerable threat for the other Empires.

The book was stolen, it passed through many hands and, finally, the intrepid knight Igor López Smith, its last owner, perished in a bonfire of green plastic. The book was discovered in an inner pocket and, since the plastic was still green, it didn't completely burn up.

Nowadays such recipes have little practical worth because today's hens, one meter tall with neither feathers nor bones, cannot supply the raw material for the aphrodisiacal sheets.

Cast of Characters

Nigel Hokogi (le japonais)
Mme. Milagra Gertznaf (the Airhead)
Dr. . . . Gertznaf (the husband)
Pompeya Malatesta (la Dafia)
Florian Malatesta (the husband)
Randolph Brown (the teacher)
Bobby Carruthers (Beanpole's husband)
Violette Carruthers (Beanpole)
Ellen Ramsbottom (Leonora and Eva *melangées*)
Ex-Balam Rey (the country)
Convent of Santa Zarabanda
Mme Felina Caprino-Mandrágora
Boris Zahareff (M)
José María Inturrimendi (Basque)
Aloisius Dupont (doctor)
Jacinto (gardener)
Raoul Somers (J. *qui bricole dans* the carpentry shop)
Daphne Fitz. James (*Mtres* E.)
Poltergeist

Exquisite Corpse Story

"Doña Milagra is afraid of the dark"

Doña Milagra is afraid of the dark, she can never be sure a blazing hand won't emerge from someplace to grab her by an ankle and leave her stuck fast while an all-consuming fire spreads from her ankles to the rest of her body, turning her into a heap of ashes. What's worst is that she always has to hide her fears from other people, because confessing them would be confessing her guilt and her fear of punishment at the same time.

These fears assail her only now and then. The rest of the time she lives peacefully, because isn't god merciful? And so she's still got time to repent. She's still young even now; once she's approaching sixty (and all according to her state of health) she'll make an act of contrition and retire to the countryside, in the meantime, why should she flay herself?

As soon as she was at the teacher's door, she gave some quick and respectful taps and went into the cell immediately.

Mister Randolph, absorbed in his work, raised his eyes to her only some moments later, but on seeing who was there, was plainly gratified.

"You here, doña Milagra, at this time of day! What is it?"

"Oh, teacher! At the risk of bothering you and interrupting your work, I've come to bring you a very urgent message."

"You've done well in coming, Milagra, and I thank you for it, even more so because right now I find myself in great need of some

first-rate advice. This afternoon I had a visitor who . . . But tell me, tell me."

Taking her affectionately by the arm, he led her over to a wide wooden bench where the two of them sat down.

"Well then, teacher. I was in bed and asleep. I went to my room fairly early today because I felt exceedingly weak, and my heart was fluttering. I must have been asleep for half an hour, when a noise in my boudoir, which is next to the bedroom, woke me. I was startled and got up to see what was going on and saw a woman whose back was to me and who was rummaging through my toiletries. I stood watching her and was amazed to see that when she found my *rouge à levres* she leaned in to the mirror and began applying it. Then, she saw my reflection in the mirror and turned to face me, smiling. She looked at me intensely and I understood at once that she was bringing me a message. I immediately took out my notebook and pencil in order to jot it down and I waited. She looked at me a few moments more and said: "Go and see Randolph, tell him the following on my behalf: "Wheat, olives, and oranges. Protect yourself from the cold with sheep's wool." Nothing more. I, naturally, haven't the slightest idea what it means, but you'll probably understand it right away. You may also know, perhaps, who this lady is. To me she's a stranger. I thought she looked about forty, she had a fair amount of down on her upper lip, blue eyes, and was wearing clothes that to me seemed inappropriate for her age: a short plaid skirt with pleats, sneakers, and ankle socks. Do you recognize her, teacher?"

"I believe so. Tell me, was there good light in the boudoir?"

"No, only a small lamp on the vanity table."

"Aha! that's why you mistook my grandfather Frederic, who was Scottish and always wore the garb of his country, for a lady. As

for the message, yes, I understand it perfectly. What's more, they're actually two messages. I'm very grateful to you, my dear Milagra. Your zeal to help us deserves praise.

"I'm only doing my job, teacher. Now I'll leave you to your work and meditations."

They stood and Mr. Brown gallantly accompanied doña Milagra to the vestibule and waited in the doorway until the car started up and set out on its way back.

Afterward, he walked a few steps across the vestibule deep in thought and, making a sudden decision, climbed the stairs to the first floor and knocked on the door of don José María Iturrimendi's cell.

Don José María, who hadn't yet gone to bed and was preparing himself for an excellent night's sleep by means of a few swigs of plum wine, opened the door immediately and was taken aback to see the teacher. Night after night, he waited in vain for doña Daphne, for whom he felt an irresistible attraction, to deign to visit him to pore over some photographs (which he kept hidden) of barbaric spectacles, like bulls running freely through a city's streets, various individuals dressed in white and seated on a dais in open gastronomical competition, the champion, who was able to down 175 fried eggs, etc. etc.

On seeing the teacher, he felt a kind of vague guilt.

"Good evening, don Randolph, what can I do for you?" he asked.

"Mr. Iturrimendi, excuse me for bothering you at this time of night," the teacher answered diplomatically, "but since you are generally in charge of food matters and oversee the kitchen, I'd like to request that you give the order, very early tomorrow morning, that we eat only wheat, olives, and oranges for fifteen days."

"Very well, teacher. For breakfast, right? The midday meal as always, isn't that so?"

"No, no. I mean we should live off *only* those three things," the teacher clarified.

"Well, I'm still a little unenlightened. Excuse me, what do we do with the wheat? There's enough of what we give to the pigeons, but it might be a good idea to grind it or soak it, don't you think?"

"I'll leave the matter in your hands, Mr. Iturrimendi. I'm sure it will work out well. If you soak the wheat, I suggest you use orange juice."

With this advice and a "good night," the teacher withdrew to his cell once again, meditating all the while on his grandfather's message.

"It's absolutely clear," he told himself. "We must be watchful and prepared with enough food. The business of the wool is obvious as well: we must only wear undervests, coats and, especially, sweaters knitted of virgin wool. Any other material should be regarded as dangerous and a tool of the Malatestas for stealing energy. Tomorrow I'll give orders to that effect and some explanations to those who are better prepared to understand me."

Somewhat more at ease, he concentrated once again on his work and was gratified to see that the chapter on the mysterious properties of galena would be done before sunrise.

"It's four in the morning"

It's four in the morning and Ellen Ramsbottom is tossing and turn-
ing on her cot, in a state of *demi-sommeil*. There aren't too many
mosquitoes, but there are enough of them to bother Ellen, who
has very delicate skin. Felina Caprino-Mandrágora is sound asleep
on another cot next to hers. That night, despite Ellen's pleas to dis-
suade her, she downed a large glass of rum to calm herself and lift
her spirits. For two days Felina and Ellen have been stationed in a
tent they brought with them when they decided to get away from
the city for a while, because both of them needed some rest and
days of meditation to bring some order into the chaos of their fears,
emotions, and doubts.

Young Lucio, who is devoted to them and whom Felina has
known since he was a boy, accompanies them, to wait on them and
protect them.

Since the area is not very safe, Lucio sleeps lying across the
doorway, wrapped in a serape and armed to the teeth.

Ellen had just awakened completely, and she heard quite
clearly a sound near the tent. Alarmed, she took up the long stick
that she always places beside her cot at night in order to be able
to wake Lucio, poking him gently when she hears some suspicious
noise. She tickled him softly and Lucio woke up at once.

"Is that you, señorita?" he whispered.

"Yes, Lucio. I heard a very strange sound. Listen—don't you
hear it?"

"Oh! That's nothing, señorita. It's only the spirit of don Pedrito, who died last month and is spitting awfully hard tonight. In these parts, all the spirits are in the habit of spitting, didn't you know?"

"No, Lucio. I don't know if I like it much. Do you think we're safe?"

"Yes, señorita. You mustn't pay them any mind, and that way they go off to look for attention elsewhere. You can sleep in peace."

"Yes, that's best," Ellen said. "Besides, we're waking Felina. Look, she has feet now instead of hooves."

Indeed, Madame de Caprino has begun to wake up, feet first as always. Soon only a couple of small, barely visible horns remain from her nightly goatish state, which disappear when she sits up and perches on the edge of the cot, yawning.

"What's going on?" she asked. "You've woken me just when I was in a delicate situation. I dreamed I ran into our dear old friend Benjamin Pérez on the Paseo de la Retorta. We were greeting each other affectionately and he was persuading me to go with him to his house, which was somewhat far away, but he showed me a bicycle he owned and assured me it could carry the two of us in comfort. So that's what we did, and I was amazed to see his mastery at handling the bicycle. When I expressed my admiration, he told me that it was nothing, what was really worth seeing was when he won first place in the final tournament held at the Vélodrome d'Hiver in Paris. In that way, talking things over, we got to his house and climbed to the topmost floor on a spiral staircase. He explained to me that he needed that altitude on account of his business. He opened a door, and we entered a very large room, completely filled with pigeons. To be able to sit down, we had to shoo several off the

seat. Benjamin absentmindedly sat on an egg one of the birds had just laid and, since I asked him why there were so many pigeons, he explained to me that at present, and given the poor state of the telephone system, he had a carrier-pigeon business. He trained them himself and could already depend on enough customers. He offered me a few sips of aguardiente and then immediately proposed that we pass the time with a splendid kind of entertainment, possible only if it was raining, which was precisely what was happening at that moment. From behind a pigeon's nest, he took out a pack of cigarettes he kept hidden there. He offered me one and led me over to a balcony. Next, he lit his cigarette and mine and urged me to blow the smoke out into the rain. So that's what we did, and I saw with surprise that this smoke had the property of suddenly hardening the drops of water, which fell like a shower of pebbles on the people going by on the street. He was having a lot of fun and, every so often, went back indoors to laugh uproariously. I saw a group of angry people was gathering and barging into the house, surely to get at us. And then you woke me up, I am so glad!"

Ellen had listened intently to the report of the dream. When Felina finished, she sat thinking for a few moments.

"Your dream is strange, Felina," she said. "In fact, I've had news of our old friend lately and I know that he actually does run a carrier-pigeon business. I forgot to tell you because of all the disruptions we've had. When we go back, I'll check what's true in the rest of your dream. I think we should clear it up. Dream-telepathic phenomena interest me enormously."

Though it was still pitch-dark, no one wanted to sleep.

"What do you think, Ellen," Felina proposed, "if we go to the beach to see the sunrise?"

"Excellent idea," Ellen agreed. "Let's go. Maybe we could also have a swim once the sun is up. Lucio, find the bathing suits and come with us."

The three set out, walking in silence. Without knowing why, they were feeling uneasy, and they went along making the least noise possible. Lucio kept up a respectful silence, Ellen and Felina walked along lost in thought.

"I don't feel good," Ellen said to herself. "This place makes me uneasy, I don't know why we've come here. Felina sometimes has some very strange ideas. Coming here was her idea, we came to rest and meditate, but I've never felt as tired as I do now, gathering coconuts all day to have something to drink. I don't like drinking coconut milk and much less washing with it, but what can I do? There's nothing else for miles around. It's a good thing I'm very fond of turtle eggs, our staple diet. As to meditating, it's useless to try given the number of iguanas. As soon as I go quiet and motion-less, trying to collect my thoughts, and I close my eyes, I've already got an iguana climbing up me. I think it's best to get back to the city as soon as possible. I'll talk to Felina at the first opportunity."

"I don't know why I feel bad," Felina thinks as she's walk-ing, "but the fact is that this place makes me very uneasy. Ellen has unfortunate ideas at times. Coming here was her idea. I feel exhausted, searching the beach for turtle eggs all day to have some-thing to eat, but I don't like those eggs at all, my liver can't handle them. Fortunately, we have coconut milk, which I love, and it's ideal for washing, it leaves your skin like silk. What's awful is that it's impossible to begin meditating. There are so many armadillos! As soon as I let my mind wander and sit still with my eyes closed, an armadillo's already on me. We should go back as soon as possible. I'll have a diplomatic word with Ellen tomorrow morning."

Lucio is worried as well.

"I don't know what to do," he wonders. "Should I or shouldn't I tell the ladies what I think, because the truth is I don't believe it was don Pedrito's spirit who was spitting so hard tonight. Spirits' saliva never becomes visible or leaves a trace, but when I turned on the flashlight a while ago to find the bathing suits, I saw, no doubt about it, signs that someone who isn't a spirit had spit. I'll have to go to the village tomorrow (even though it's so far away) to ask if there have been any rumors about the Güero Trabuco, who may be prowling around these parts again."

They kept on walking in silence until Ellen stopped and pointed at a distant place to her right.

"Look, Felina," she whispered. "So many fireflies!"

"They're not fireflies, señorita," Lucio said. "They're surely the gringos. I forgot to tell you that yesterday morning, when I went to the estuary to see if I could catch any mullet, I discovered a small house where some gringos are living. Well, maybe they're not gringos, but they look like foreigners. What caught my attention was that an extremely blond lady was hanging out to dry, draping them on the bushes, almost two dozen corsets. It's strange that so many corsets have been brought to this remote place where there's no reason to dress up. What you're seeing there isn't fireflies, it's flashlights. No doubt they've gone out fishing and are coming back now."

"Let's get closer," Felina proposed, "and we'll watch them. If they seem like nice people, we could make friends with them."

Ellen agreed and they headed off that way. Twenty minutes later they were close enough to see, through the leaves of a patch of jimson weed in which they were hidden, a not-so-large house of stone with a palapa-leaf roof. The railed porch, fairly spacious, was illuminated by the light coming from a window. No one could be

seen except for several enormous crabs that crept quietly about, but noise from an argument could be heard indoors. From where they stood, they were able to hear perfectly what the people were saying.

"You never want to listen to me, Florian, and look what happens: you're stuck with 250 gloves now, all right-handed. Brilliant! The corset business was running admirably, why did you want to go into gloves too? Captain Fitzgerald must be on the high seas by now, and he's surely having a good laugh thinking how he tricked you."

"My dear Pompeya," a voice calmly replied, one so familiar it made Ellen and Felina shiver, "it's possible Captain Fitzgerald wanted to cheat me, but I'll make use of these gloves in such a way that they'll double in price. Besides, just as you say, the captain must be on the high seas and he'll get his comeuppance [his voice becomes louder and takes on a prophetic tone]. I sense a hurricane brewing in the Sargasso Sea, I see this hurricane bearing down on the coast of America. It obeys my wishes, it doubles its speed and swoops down upon the corvette of poor Captain Fitzgerald! And voilà, all of a sudden he's grappling with the immense waves . . ."

"Listen, papa," interrupted Pompeya (whom Felina and Ellen could now see through the window). "Don't be ridiculous, you're suffering from an occupational hazard, you haven't got any audience here, and don't come to me with this nonsense about hurricanes obeying your wishes! Instead let's look at what's inside the crates the captain's brought. We need to remove all the corsets and hang them outdoors to keep them from getting mildewed. They always arrive a little damp. I'd also like to see if he brought the new, Egyptian model with pyramid-shaped false hips."

"Very well, mama, call the others, they're surely having coffee in the kitchen. Bring me a cup too, please."

Ellen and Felina are frozen in fear and surprise, but, devoured by curiosity as well, they stay hidden so as to observe the house and try to understand what all of it could possibly mean: Can it be that the dark enterprise of Black Magic still exists? ... Why so many corsets? ... Who is that captain they speak of? ... They ask each other these questions in whispers, but Lucio, who has observed everything and who often has great insight, says to them a single word in a lowered voice: "Contraband!"

Dream Narratives

"Javier's birthday"

Javier's birthday (19 August). I buy him a Roman soldier outfit (helmet, shield, breastplate, etc.), its quality is fairly poor, and I end up slightly worried. At night I dream I'm in an unfamiliar house. I go into a very large room. Sitting at the table (perhaps eating) is a man of a certain age dressed as a Roman soldier. I mysteriously understand (as happens in dreams) that he's a relative of mine, I get closer and confirm with satisfaction that his outfit is substantial and of good quality (unlike Javier's). After that I don't know what happens, the dream becomes very vague or perhaps I remember nothing else on waking.

20 August. I'm reading the Borges story titled "Deutsches Requiem" and I'm very struck by a few phrases: ". . . Arminio, when he cut the throats of the legions *of Varo* in a swamp, did not know himself to be the forerunner of a German Empire."

Since I've never known anyone named Varo who isn't a member of my family, I'm curious enough to look it up in the Larousse and I search for the name "Arminio." I find the following: "Arminius, Latin name of Hermann, chief of the Cherusci, in the era of Augustus and Tiberius. Taken hostage in Rome, he served in the Roman armies, and after his return to Germany, destroyed the legions of *Varus* (9 BC)."

I look for Varus in the Larousse and find the following: "Varus (*Publius* Attius), Roman general, died in the year 45 BC. He

fought *for Pompeii* from 49 to 45 BC. *Exiled in Spain* after Thapsus, he was defeated in the naval battle of Carteja and killed in Munda."

There is another Varus (*Publius* Quinctilius) who lived until 9 AD, *the son of a Pompeian* (surely the one above) and it was his troops that Arminio defeated. While looking for him in the dictionary, I found the other Varus (his father, no doubt), who was in Spain, in Andalusia, since he died in Munda (the ancient name for what is now called Ronda.)

"I went to visit Javier and Amaya"

I went to visit Javier and Amaya and found their parents at home as well. After a while, I realized with surprise that the whole family seemed to have made a sort of nutritional discovery based on a great spiritual advance they'd achieved. I saw that all of them were working with pieces of modeling clay, shaping them into hollows, something like tiny cups and casserole dishes that later could be eaten, proving highly nutritional. I thought that thanks to a powerful physical influence over the clay, they could change its composition and turn it into something digestible, but I saw that that wasn't it, instead the clay didn't change at all, but they could control their bodies thanks to their great spiritual advance and, in that way, digest the modeling clay with great nutritional benefits. All that was needed was for the clay not to be in compact balls, but instead molded into hollow shapes with thin sides, to contain the greatest possible quantity of air.

I was amazed but worried, because I immediately knew that this was not "objective," though it seemed so, but that it was a *personal* manifestation of earthly magic with no true relationship to the universe, and that, because of this appearance of spiritual conquest, they would be left unable to make any true advance.

"I'm bathing an orange kitten"

I'm bathing an orange kitten in the sink of some hotel, but that's
not so, it seems instead that it's Leonora, who's wearing a large coat
that needs to be washed. I spritz her with a little soapy water and
keep on bathing the kitten, but am very puzzled and disturbed,
because I'm not at all sure whom it is I'm bathing. Somebody, one
of the two, tells me that Mr. Gamboa has just left for Brussels and
before leaving sent me a certified telegram commanding me to
paint the facade of his house turtledove gray. A mortal anguish
comes over me and at that moment someone knocks on the door, I
go to open it and see a person wrapped in a dark cape and wearing
a summery straw hat. He tells me he's been sent by Mrs. Yellow. Of
course! I *understand* at once that yellow, as a decisive and concil-
iatory force among colors, bodes well for me. I see him in and he
seems to me somewhat hairy in the unnatural way of a stage actor.
The cat-Leonora have disappeared. I feel a sudden terror, now I'm
going to learn something I'd be better off not knowing. This mys-
terious man will tell me, in fact, he sits down and begins to take
off his disguise, the hat, the excess hair, the beard, etc., and then I
recognize Juan. He laughs a lot and he tells me: "*Quelle bonne farce!*
I came to warn you about *something*." Then I began to cry inconsol-
ably because I understood at once what *something* meant. I also felt
a great terror, and I cried and woke up. Now I don't know anymore
what *something* meant (two in the morning) and I think and think
and I cannot remember what it was. I'm surely in a very bad way,

REMEDIOS VARO

if I imagine Juan, right now, coming into this ordinary place, with no orange cats or anything, I wouldn't know how to tell him I've understood because in fact I've forgotten, I only know it doesn't seem to be entirely *him*, but instead a

"We were all living together"

We were all living together in the same house, a fairly large house and perhaps not in the city, because the street, very steep, looked like a village street cobbled with those rounded stones like petrified eggs.

It was early in the morning and we were arranging the carpet in Leonora's bedroom. It was a red carpet and had a very soft and silky pile, it was surely Oriental. We had decided that the best way to clean it and position it was by cutting it into slightly elongated rectangles, which we positioned one next to the other in a haphazard way. To us it seemed like playing dominoes and we decided we could use it every now and then for that game. Afterward, we went out to the street to take a walk and do the shopping for dinner. Gabi and Palito were playing and running around the house, and the baby was napping.

Leonora had recently had a son and this child worried us a great deal because at birth he seemed too small and, what's more, he was born with a red sword at his side, and this sword was part of him, it was alive and was, though a sword, also flesh with blood circulation.

When we went out to the street, we saw a red convertible pulling up, somewhat old-fashioned but brand new and with a touch of elegance superior to that of modern models. In the car were two men who closely resembled each other. Both had beards, not long ones, but rounded from ear to ear, and luxuriant, curly,

fluffy black hair. On seeing them we were quite disturbed because we understood at once who they were. "Ah, the Henri brothers!" I said, "What are we going to do, Leonora, where will we receive them?" Walter went up to them to ask what they were looking for, since they were staring all around, as if looking for the number of some house. What's more, one of them had now gotten out of the convertible and was poking his head in the door of our house. "Nous sommes les frères Henri," they answered. Meanwhile, I said to Leonora that it would be best to receive them in her bedroom, since the carpet was clean and recently arranged, but Leonora answered that that was impossible because there were probably still some bits of meat the cats hadn't eaten left in her room and the meat's pungent odor would bother the Henri brothers. She hurried to the house and went inside with them. When I went in, I saw that she received them on the landing of the staircase that led to the rooms on the other floor. I was amazed to see that Leonora had been able to re-cover the floor of that spot with a silky carpet of a color between yellow and golden ocher with some sienna figures. This carpet was cut into rectangular pieces and arranged like the one in her bedroom. I couldn't imagine where she had gotten such a carpet. Everyone was sitting and chatting. One of the Henri brothers had taken on a different consistency from the one he'd had, as if he had taken part of the substance of the other brother, who had turned into something a bit blurry and unimportant. Right away, I saw that the main Monsieur Henri was looking at Leonora with a devouring interest and that she had already realized that this man *knew* that he was the one so long hoped-for and the one who, from then on, would be taking the reins in his hands. And I cheered up, but I felt that that man was perhaps regarding her and all of us as ignorant and provincial people. I didn't like that and so

I made an effort at conversation, to give him a better impression of us. "You know, Monsieur Henri, don't think we aren't up to date, even though we live here, in this far-off country, we are very much up to date." Monsieur Henri looked at me somewhat disparagingly and muttered something like "Bah! A kind of Carmen!" I was extremely annoyed and hell-bent on his knowing that he knew that, although I wore gorgeous high-heeled pointy-toed Italian shoes, I was also totally pervaded by the formula piR2, and so I kept saying to him: "Don't think, either, that we're here against our will, we want to be here, because we like it a lot, and I tell you once again that we are completely up to date." He barely heard me, so I decided to tell him that, in addition to that, we were very rich and had more than enough money to go to Europe if we wanted to, but I couldn't tell him because Leonora stood up all of a sudden and, looking at him intensely, said to him: "Ah! I can see that you're a specialist in infants, I must show you my son." Then she ran off and brought the baby lying in her arms. Monsieur Henri looked at him and said, "Yes, I believe he's a newborn." We all explained to him that he hadn't just been born but was some months old. "I do believe he's a newborn." Monsieur Henri repeated. Then the baby began to speak and said: "Naturally, you believe that, because I forgot to bring something, I'm going to look for it," and leaping to the floor, he started to walk to his bedroom. Nobody found this strange because we were used to hearing the baby speak. On the way, his red sword fell off and he quickly leaned over to pick it up and put it in its place. Gabi helped him lovingly. Following them, I said: "Oh! Don't you see it's gotten all dusty? The floor is very dirty, the sword might get infected." The children paid no attention to me, and I thought they were right, that the sword was, after all, an external organ and no more delicate than a leg. My worry was because I

knew that, outside the body, that sword was somewhat disturbing, and that we all wanted him to have it inside his body, as happens with everyone else. That was precisely why Leonora wanted to consult the brother Henri on the case. (I forgot to say that Monsieur Henri had a dark-skinned face, with large black eyes lengthened at their corners with a long dark shadow like Egyptian eyes, I thought at first that he was wearing makeup, but on observing him closely, I realized that it was natural.)

(*Saturday night to Sunday, 22 to 23 March.* Two days later, the bearded Frenchman turned up at Leonora's house, and Bill (who has a twin brother) at mine, at the same time, we received each of them under the same circumstances, getting up from our afternoon naps, hair disheveled and barefoot.)

"Sunday. We're in the house of the Bal y Gays family"

Sunday
We're in the house of the Bal y Gays family (the house is very different from the one they actually live in). Jesús has called us together to see if he can clear up the source of a postcard containing several sentences that slander him, one sentence especially (I can't recall it). It's a postcard of the "poison pen" variety, menacing. Walter and I, Manuel, Gerardo, Mario Stern have come to this meeting, along with several others I can't remember.

Walter tells me that Mario Stern's mother will arrive later on, but I don't see her. I feel very tired and decide to lie down on one of the two beds in the living room. Before lying down, I notice a strange rug on the floor that carpets the entire room. It's the color of chickpeas and made of small rectangles joined in such a way that they don't all lie flat, but instead some stick out more than others. I understand that it's something that Rosita has made. Before I lie down, I roll up my hair on those plastic curlers that are used in beauty salons. I lie down and see Rosita lying on the other bed. Then I say to her, "Rosita, you don't mind if I use this bed? I guarantee you, I'm impeccably clean. I took a bath only a half hour ago and, besides that, all the tests they just did show that I'm in good health." Rosita assures me that she doesn't mind if I use the bed. The matter that is to be discussed with Jesús about the postcard has to be discussed at twelve midnight, and until that hour arrives, everyone mills about.

"Monday. I look out the window"

Monday
I look out the window and am annoyed to see the mailman cross-
ing the street in a big hurry and wearing my beige Merino shirt (it's
an English shirt that Eva gave me). He's wearing the shirt strapped
around his waist with a blue woolen Michoacan-style belt, also
mine (which doesn't exist in reality). I'm outraged and run to the
door and downstairs to hunt for the mailman so that I can take my
clothes away from him. But I can't find him and I see an old suit-
case (a gray suitcase that I brought to Mexico when I came here). I
understand that that's where my shirt must be and begin taking out
some clothing. I find, in addition to my things, a jacket of good-
quality cloth that belongs to my close friend Bill. I decide to keep
this jacket until he can come to retrieve it and I hang it on the back
of a chair so it won't get wrinkled, but I see that the right sleeve is
turned inside out and rolled up. I mean, it's folded several times as
if to shorten it and as if it had been worn that way, inside out, while
the other sleeve was worn normally. This seems physically impos-
sible to me and leaves me at a loss.

"Eva and I were supposed to take a very long trip"

Eva and I were supposed to take a very long trip (perhaps around the world). It was time to board the ship. I asked her if she thought passports and identification documents were necessary, but she said no. We boarded and then I realized that some friends of Eva's were coming as well, a married couple I didn't know and their daughter, a very beautiful young woman. The ship was very small and broad, and I saw only interior corridors, but no deck, or air, or sea, or anything. I sat down to write two very important letters and left them (before putting them into their envelopes) on a table, and when I went back to retrieve them, I saw with annoyance that Eva's gentlemen friends had dunked one of the letters in the oil-and-vinegar dressing of a salad they were eating and the other letter was soaking in the juices from some pieces of stewed meat on another plate. I became extremely angry and fought with them, but I had no time to straighten things out because at that moment we reached London. We wanted to disembark at once, but immediately at the gangway a street began and there stood a customs agent who asked me for my papers and, since I didn't have them, wouldn't let me pass. So I tried to win him over by smiling and winking at him and I promised him that it was just to take a short stroll around London and no one would find out. He agreed to the stroll and I reboarded the ship to spruce myself up. While I was looking for my dress, I realized that next to the ship was a sidewalk café and that three women who looked Mexican were speaking Spanish there. One was saying, "I

REMEDIOS VARO

don't know what to think anymore, I haven't gotten a letter from him in a long time." Another one answered: "You shouldn't worry because Monterrey is far away and, besides, he's busy with serious things now and doesn't have as much free time." While they were saying all this, they were looking straight at one another, as if conveying things of great hidden meaning. I immediately understood it had to do with the smuggling of marijuana.

"Eva and I were at my home, in the living room"

Eva and I were at my home, in the living room. It was this place, but, nevertheless, different from the way it is. Through the window you could see the avenue, which was much, much wider. The buildings opposite were very far away. We were looking out the window and, all of a sudden, Eva said to me, "Ah, Paalen just went into that hotel across the way [in reality, there is no hotel]. Now I feel calmer because I didn't know for sure whether he would arrive or not." I replied that the best thing for her to do would be to phone the hotel right away, but in the meantime I realized, leaning out on a sort of balcony (which doesn't actually exist), that Paalen wasn't going to be staying in that hotel and that he had come to look for things that belonged to him. I could see him because the hotel was now very close and from the balcony of my house (which doesn't actually exist) I saw the patio of the hotel. I showed Eva how they were carrying out a large drafting table, a tall and narrow piece of furniture, like a bookcase, an easel, etc. They were stowing it all very quickly on a small, wheeled platform and they whisked it away, everything teetering and in danger of falling off. We stood there baffled and remained in my house, which was now completely different, very large and more like the ground floor. I had applied to my face a beauty product for the skin, a liquid that, when it dried, left me as if covered with salt (something similar to tears when they dry). We were walking around the house, which had a huge kitchen with a black-and-white marble floor, that is, some large white

slabs separated by narrower strips of black marble. I went into the kitchen for a moment and was annoyed to see there was quite a bit of disarray and filth and any number of tomato skins all over the place. All at once, there was a knocking at the front door and Eva and I were very distressed to see it was Paalen, accompanied by some people. Our distress was due to his having come to search for certain paintings in order to show them to several potential buyers, and these paintings were not in their usual, appropriate place, but instead were just about everywhere and on an easel in the kitchen. I was also distressed at the thought that my face was covered with that saltlike substance and didn't want Paalen to see me like that. I didn't have time to run to the bathroom to wash my face and I met up with him. He greeted me, without any of the display one makes upon seeing someone after being a long time apart, instead it was if we had seen each other yesterday, and he wanted to introduce me to a short man with a very round head who stood there with him. I excused myself and ran to wash my face. I removed the salt and went to look for him and saw with annoyance that Paalen was leading into the kitchen an elegant lady in a mink coat (without its being Mrs. Gelman, I associated the lady with her), in order to show her his paintings that were there on an easel. Both Eva and I were annoyed that Paalen would find such disarray in how his paintings were stored. The elegant lady and Paalen were about to enter the kitchen and I heard Paalen say: "Oui, ma chèrie, dans la cuisine . . ." I didn't know what to do and while looking at the kitchen was comforted by the thought that, in any case, it was a beautiful kitchen with a marble floor and an enormous, solid table and a few other pieces of elegant furniture, all of them antique and beautiful.

"I dreamed I was asleep in my bedroom"

I dreamed I was asleep in my bedroom and a loud noise woke me up. The noise came from upstairs, from the studio, and it was as if somebody were dragging an armchair. I thought that this meant someone was trying to get in from the terrace and was pushing the armchair that was against the door. I was alarmed and it seemed wise to let whoever it was know that I was awake, but to do so without his realizing I knew it was him, so that he could leave before anything worse happened. I got up and from my bedroom door called upstairs to my cat, "What's all the racket, Gordi?" I took another step forward and at that moment I sensed with frightful horror something behind me that instead *was coming out of myself* and at the same time, I realized it wasn't true that I'd heard that ominous sound from upstairs, but that I had somehow wanted to hear that threat outside and above, whereas in truth it was always beside me or *in me*. This "thing" behind me filled me with enormous terror and with a sensation of heavy, tormented sleep from which I struggled to wake up in order to defend myself, but the mysterious creature grabbed me tightly by the back of my neck, digging in with his fingers as if trying to join those two long, thin muscles at the nape (or that I believed I had there) and with his other hand he squeezed the bridge of my nose. All the while, he was saying: "This is so you don't wake up, I don't want you to wake up. I need you to sleep soundly so that I can do what I have to do." He didn't harm me and I felt no pain, but the terror I felt was much

worse than everything else and I didn't want to go to sleep. "He" gave me a last, still stronger squeeze, and as I felt myself dropping into a deep sleep, I woke in reality, in great torment and drenched in sweat.

"I had discovered an extremely important secret"

I had discovered an extremely important secret, something like a part of the "absolute truth." I don't know how, but powerful people and government authorities had found out that I possessed that secret and considered it extremely dangerous for society, since, if it were known by everyone on earth, the entire existing social structure would collapse. So they took me prisoner and condemned me to death. The executioner took me to a place that seemed like the wall of a city. From either side of the wall an earthen slope dropped very steeply.

The executioner seemed very pleased. I felt great fear and great distress. When I saw he was already preparing to behead me, I started to cry and pleaded with him not to kill me, it was still too soon to die and he should consider that I still had many years of life ahead of me. Then the executioner started to laugh and to mock me. He said, "Why are you afraid of death if you *know* so much? Having so much wisdom, you shouldn't fear death." Then I realized suddenly that what he was saying was true and that my horror wasn't so much of death, but instead because I'd forgotten to do something of the greatest importance before dying. I begged him to give me just a few more moments of life so that I could do something that would allow me to die in peace. I explained that I loved someone and needed *to weave* his "destinies" with mine, since once this weaving was done, we would stay united for eternity. The executioner seemed to find my entreaty very reasonable and granted me some

ten more minutes of life. So then I acted fast and wove around myself (much as baskets and hampers are woven) a sort of cage in the shape of an enormous egg (four or five times larger than me). The material I used to weave it was like ribbons that kept materializing in my hands and which, without seeing where they came from, *I knew* were his substance and my own. When I finished weaving that egg-like object, I felt at peace, but I kept on crying. Then I told the executioner that he could kill me at once, because the man I desired was *woven* with me for all eternity.

Incantation

Tetratitroluna
Lunatitrotetra
Scatterlight
my solitude
Mud!
Hurricanoctur
No
Soul disheveled
Star light luce
my tempest
O nightingale wait!

A Part of A's Life and Alchemical Recipe

A Part of A's Life

A part of A's life then the journey, in that other city A meets up
with X (they do *not* physically resemble each other, they are *comple-
mentary*), at the beginning only small coincidences, later on X's
stories (including occasional photographs to document corners of
the house, favorite animal, party or gathering, etc.) specifying *dates
and days* that reveal the coincidences (the place where A lives in
this other city had some *traces* when A first arrived, the chair A sat
in was slightly warm, etc., etc.). Of course X possesses some objects
that A believed were lost or whose disappearance was murky.

The hair, it might have been possible that the *only hair* was
somewhat violet, made up of the other two, one red and the other
bluish (bluish black).

Almost invisible freckles but on the one, dark, on the other,
light (as if the spots on the one had been formed using the skin of
the other the way a stencil is made).

Alchemical Recipe

Egg No. 5

31 October 1961

Fresh thyme
hair (from the two women)
incense
saliva
pomegranate
beeswax
Stellar limb (filament)
Mercury (two drops)
ash
cobalt (powdered)
olive oil

On the ground: Two orange-colored flowers (of those often used for the dead), another unknown flower, a sprig of ? a beaten raw egg (first one laid) cornmeal, saliva?, beeswax, pomegranate.

Thyme. My grandmother is rushing around with more than enough thyme to make *huevo en gazpachuelo* soup, but she stumbles, she stumbles on the tail that outrageous tail that often intrudes into the hallway, but never mind! moving ahead she can run into the opaque glass but it splits in two, inside are three more grandmothers but now she doesn't know which is which, straying into the store it's often incredible what one finds in one's mouth.

Hair. Without a doubt it's blond, but its origin unknown, it was wrapped around a stone, and very well wrapped, it took us ages to unwrap it and inside was a lighted candle, I don't know what became of the stone, so it goes little girl! But don't suppose for a minute that that street is safe, showing red stockings doesn't get you anywhere, just as two rhinoceroses can meet one another, provided they can sniff eau de cologne in time, cordial, not cordial, case closed.

Incense. Of course, the church but that altar boy, it's impossible, untangling his feet is much easier, dish depraved, lathe, that's it, to give it form, an elongated shape like a spindle for spinning and afterward spinning a golden thread you can even weave a warm blanket, you would also use it as a rug and in case you need a tablecloth you could paint the table white, oranges scattered all over the place, they knock three times on the door and a big black dog comes in and sings in a shrill voice.

Saliva. Saturnino runs wildly after a butterfly, I don't know where it's gone, but it's in some crevice that widens, Saturnino enters through it, you can't run more quickly because there are many lines where clothing is hanging to dry, but it's not everyday clothing, it's made of raw silk, this doesn't matter because the enclosure where the butterfly is now flying is full of silkworms that endlessly go on spinning raw silk, the butterfly is the postman-messenger of solid things, it suddenly falls asleep on a shirt.

Pomegranate. You see, what a thing, if you have time you can be in two places at once, stepping on only the cracks in the sidewalk, I believe, but I am not sure and that's why it's best to go into the small shop, surreptitiously, and begin once again, she not only had

a broad face but was also covered in a soft, agreeable fur and when sneezing scattered around her hot and pretty sparks, I don't believe it's a good thing. A stairway, a door, sand on the floor, water is boiling in back and there's too much steam.

Beeswax. Certainly and with the security given by his venerable beard he spoke thusly, "Go buy me some good tobacco for my pipe, then we'll talk about Narcisa," I don't like this, talking with him it's clear that the business of the beard and of Narcisa is a lie, tobacco costs much less that way and one needn't trust those commissions. Three or four clocks strike 23:00 with twenty-three chimes, I don't know if the woman who's the concierge set it up that way, but it's unpleasant and uncertain, by placing the clock upside down it might sound better.

Filament of stellar limb. Hot heart, three times hot, the cascade of sun comes in and goes out in an abundance of excess, as it comes in and goes out it collides with the furniture and ruins it, it should run in a single direction but it runs in many different ones, as many as there are windows, it comes in, collides, and sends a stream of sun through each window, outside they gather it carefully to make honey, I don't believe they know how to use it and I'm afraid it may give them a case of hives.

Mercury. Salt on a tableful of magnificent mosquitoes, dressed in a bit of tulle, the salt has sprinkled them by pure chance on falling from the ceiling where there's a certain accumulation, that accumulation is not intentional, it's the steam from the soup that's accumulated for thirty-nine and a half centuries, something impossible to prove because of the intolerance of the well-known metal

lead. In this situation a bullfight or a harefight is all the same, prac-tically speaking neither the one nor the other produces that dense green thing we need to varnish ourselves.

Automatic Writing

"But it isn't so"

But it isn't so, fallen Feather, bird's feather, of course, and it's not
even aware of those products to prevent baldness, well! nothing is
clear, three men veiled in the secretive manner of those who must
conceal themselves because they KNOW, but next to this knowl-
edge that is not of the day-to-day, they haven't the slightest idea of
the day-to-day, and no wonder! they fall into a manhole, carelessly
left open in the middle of the street because it was necessary to fix
the sewers, once down there and the veils dirtied, they had to aban-
don them, walking walking, it's not exactly that, swimming, so did
they arrive? who knows, it sounds like midnight, to be classically
black, I mean, blackly humorous. An innocent life, nothing to fear,
neither pain nor guilt, the square meter around it is completely safe,
but— — — — So many bees have come in and started making
honey that there's already almost a meter and it reaches halfway up
my body, I don't know what to do if they keep on I'll end up buried
in honey, adorable way to die.

"Gusts of carnitas"

Gusts of carnitas at room temperature and numerous groups of opulent concierges run swiftly westward, from the east arrives a cloud of ardent swallows that collide with them inevitably . . .

*

Several groups of succulent concierges run swiftly to the west . . .

*

Gusts of carnitas at room temperature and clouds of scraps of newspaper follow in the wake of the sumptuous concierge who, riding on the back of her favorite young goat, runs to the west, three pairs of monumental saffron-colored plumbers collide with her, the whole group bursts into a cloud of mosquitoes, but I say it's muscatel! Hey buddy, you're drunk. Me? No way! Look at that great aim! The bullet's tracing an elegant parabola without considering . . .

*

Dense groups of indescribable concierges, on the backs of gigantic young goats, run swiftly to the west, from the east comes a cloud of ardent swallows that unavoidably collide with them, but the unknown vagabond comes zigzagging, licking leg calves in a hurry

and downing any old swallow, green, but not very sensible, mailmen flatten themselves against the walls to free up the way and because of all the agitation, the wrinkled old scraps of newspaper rise aflame in the air and explode with pyrotechnical mastery. The mallows and turds, a forgotten hand and those mysterious things that float, that tangle around the ankle at night are turning gray from worry, for they sense the arrival of the cement. Ave Maria Purísima, dear girl! Let's run, here comes the flasher, wrapped in a great whirling cape, whirls or wheels? ah yes! wheel, wheel of fortune, of bicycles and tricycles, the neighborhood boys ride all over throwing stones over the wall that fall to the patio and burst releasing their seeds, sweep them up quick, Maria, I don't want any more monoliths! and, please, sprinkle a little disinfectant behind the door and the wall, there are really too many flies!

All this and much more is boiling in the vacant lot next to the house. It's the roadbed of a future street, but the cement and everything else is still very far off.

Images in Words

Within a grove in great disarray, a sort of tree (the cell), inside a creature who is knitting with her own tresses a substance that lengthens and stretches out toward the horizon, a river separates this from the other side where there's a building with peoples, sages etc., who observe this scene with a sort of microscope, telescope. On the river a bridge, someone is crossing it in order to bring a kind of letter or message *to the knitter*.

Also, the knitted fabric can be captured by *someone* who receives it in a purifying box (the box will be half musical instrument and will represent harmony, naturally, the fabric keeps getting undone inside the box).

Goblet forgotten on a table, barely any ruins left, desert (sand) invades everything, from the goblet flows a miraculous water that keeps expanding into *a stream*.

Encounter with those twin brothers (communicating vessels) could the legless animal dressed up as a lizard accompany me? after all, we're in Carnival

Don't forget the ray of
light that cuts across
the shadows upside down
the gathering of people with architectural perspectivoid depths in
their chests
the character in dead leaves (strong
wind that drags them along and shoves them
through the door)

careful
don't forget the ray of light
that cuts across
the shadows upside down
the vehicle with celestial traction

Hair salon—psychoanalyst
(cerebral strip being ironed)
~~vegetal cathedral~~
~~Staining and peeling identical with the man passing by~~
~~creature who embroiders the fabric that~~
~~covers the earth~~
~~the bearded men who roll along~~

Always the blade of light that gives birth to a creature by means of
the goblet of a kind of still life
The dream through the diagonal

DON'T FORGET!

Don't forget

~~The knitting woman (there's a gouache)~~

three characters in an interior, folds etc. form wheels that connect
to pulley system that forms machine,
star ✡ etc.
character moved by pulley that
comes from celestial body.

~~character from peeling wall participating in something with~~
~~another character who is real.~~
Metamorphosis
Mimicry
The abandoned room, someone inside the table, inside the armchair
as well, perhaps inside the wall— — — —

Questionnaire

1. Were you a Surrealist before arriving in Mexico?
2. Is there something in the Mexican milieu that tends to stimulate this particular art form?
3. Where do your ideas come from? How do you arrive at the specific subject of each painting?
4. When you begin a painting, have you already decided what form it is going to take? Or is it a spontaneous process by which the subject develops automatically?
5. Do you believe that Surrealism is in decline?
6. Is it an art form for which there is general demand, or is it primarily for collectors?
7. Overall, what do you think Surrealism has contributed to art?
8. Please give a brief summary of your career.
 A. Where were you born?
 B. Where did you study art?
 C. When did you first become interested in Surrealism?
 D. Are you a writer as well as a painter?
 E. Are there any particular contacts or events that have influenced your style of painting?
 F. Exhibitions.

—m—

1. Yes.
2. I believe I would paint the same way anywhere in the world, since it originates in a particular way of feeling.

3. In the same way other ideas take shape: through inspirations, associations of ideas, etc.

4. Yes, I visualize it before I begin painting, and try to make it conform to the image I've already fashioned.

5. I don't believe it can ever go into decline in its essence, given that it is inherent in humankind.

6. Because of the growing number of works devoted to this art form and the number of reproductions being published, I believe it's of general interest.

7. To the same degree as psychoanalysis it has contributed to the exploration of the subconscious.

8. A. Anglès, Girona. (Spain.)

 B. At the Escuela de Bellas Artes in Madrid.

 C. I got in touch with the Surrealist group in 1937.

 D. I sometimes write as if I were making a sketch.

 E. Consciously, no. Nevertheless, there's no doubt that people or events have influenced the way I paint in an unintentional manner.

 F. Paris: Two group shows in 1938; Mexico City: Galería Diana (solo show); Galería Excélsior, Proteo, Antonio Souza and the Palacio de Bellas Artes (group shows).

*Comments by Remedios Varo
on Some of Her Paintings*

Portrait of Baron Ángelo Milfastos as a Boy (Retrato de Barón Ángelo Milfastos de niño), 1952

Juanito, huge congratulations. Please don't mind that this drawing is so bad, because it's a document of great historical value. What it is is the only portrait that exists of Baron Ángelo Milfastos when he was a boy and began cutting off the heads of his aunts. He died later on by hanging, but it was a great injustice and a judicial error. He was no criminal but rather the inventor of a new and magnificent device for sharpening knives, in cutting off heads he intended merely to test the device.

Revelation (La revelación), 1955

Here the subject is time. That's why there's a clockmaker (who in a way represents our ordinary time) but a "revelation" comes in through the window and all at once he understands a great many things. I've attempted to give him an expression of astonishment and enlightenment. Around him there are a number of clocks that all tell the same time, but inside each one there's *the same character* in very different eras, I achieve that by means of outfits that are characteristic of very dissimilar eras. Each clock has a barred window as in a jail.

Hermit (*Ermitaño*), 1955

This is a hermit, he's already outside ordinary time and space, his body is formed by two triangles that as they intersect, one with the vertex pointing upward and the other pointing down, form a six-pointed star, symbol of time and of space in the ancient esoteric teachings. Within his chest he has Yin and Yang, the most beautiful symbol (to my mind) of inner oneness, since the symbol *is already surrounded by a circle* and has become one.

The Flute Player (*El flautista*), 1955

The flute player is putting up that octagonal tower lifting the stones by the might and impetus of the sound of his flute. The stones are fossils. The tower is octagonal to symbolize (somewhat vaguely, I have to say) the theory of octaves (a theory important in certain esoteric teachings).

Half the tower is as if transparent and is drawn only because it is being imagined by the one who's building it.

Roulotte (*Roulotte*), 1955

This caravan represents a true and harmonious home. Inside it are all the perspectives and it moves happily from here to there, the man driving, the woman serenely making music.

Fellow Feeling (*Simpatía*), 1955

This lady's cat jumps up on top of the table creating the havoc that is customarily tolerated if one likes cats (as I do). As she strokes him so many sparks leap up that they form this whole, very complex electrical contraption. Some sparks and electricity fly at her head and are made use of to get a quick permanent wave.

Theft of Substance (Robo de sustancia), 1955
That character in the background simply commandeered the substance of those five other characters and that's why the robes were left empty.

Discovery (Hallazgo), 1956
After much coming and going, those travelers at last find that species of great pearl in the grove in the background. That luminous small sphere or pearl represents inner oneness, the travelers represent peoples who seek to reach a higher spiritual level.

The Knitting Woman of Verona (La tejedora de Verona), 1956
What's happening here is obvious, that lady who is knitting fisherman's rib is making animated characters who leave through the window.

Three Destinies (Tres destinos), 1956
Those three characters quietly devote themselves to doing what they like, they don't even know one another, but there is a complicated machine from which pulleys emerge that wrap lines around them and cause them to move (they believe they move freely). That machine is moved in turn by a pulley that goes to a star, and it moves the whole. That star represents the destiny of those people, which, unbeknown to them, is mixed, and one day their lives will cross and will be mixed together.

Au bonheur des dames, 1956
Creatures fallen into the worst mechanization, all their body parts are now little wheels, etc., the store sells the parts they want to

acquire to replace the used ones. Creatures of our age, with no ideas of their own, mechanized and soon to pass into the state of insects, ants in particular.

The Juggler (*El Malabarista*), 1956

This is a conjurer, he's loaded with tricks, and color, and life, he carries all sorts of animals and miraculous things in his caravan. Before him is "the multitude," in order to be more of a "multitude" they even wear a common garment, an enormous piece of gray cloth with openings to put their heads through, they all look like one another, have the same hair, etc.

Harmony (*Armonía*), 1956

The character is trying to find the invisible thread that unites all things, that's why he's stringing together, on a musical staff of metal threads, all kinds of objects, from the simplest to a scrap of paper containing a mathematical formula, which is in itself already a great jumble of things. After he manages to put the different objects in *their place*, by blowing through the clef that holds up the musical staff, a music should emerge that is not only harmonious but also *objective*, that is, able to move the things that surround him if that's how he wishes to use it. The figure peeling away from the wall and collaborating with him represents chance (which so often intervenes in all discoveries), but objective chance. When I use the word *objective*, I understand it to be something outside our world, or rather, beyond it, and which finds itself connected to the world of *causes*, and not of phenomena, which is our own.

Tailleur pour dames, 1957

This is the showroom of a ladies' dressmaker. One design is for travel, very practical, shaped like a boat in back, when reaching a stretch of water it plops down backwards, behind the head is the rudder, steered by pulling on the ribbons that drop to the chest and from which a compass hangs. All of it serves as an ornament, too, on dry land it rolls along, and the lapels act as little sails, as does the walking stick, inside which there's a rolled-up sail that unfurls. The seated design is for going to those cocktail parties where not even a straight pin can fit and one doesn't know where to put one's glass, much less sit down, the shawl is woven from a miraculous substance that hardens at will and serves as a seat. The design on the right is for widows, it's made of an effervescent fabric, like champagne, it has a little pocket for carrying a vial of poison, it ends in a very flattering reptilian tail. The tailor has a face drawn in the form of scissors, his shadow is so rebellious that it has to be fastened to the ceiling with a pin.

The client who is considering the designs unfurls into two more people because she doesn't know which of the three designs to choose and her replicas, to either side and somewhat transparent, represent the state of doubt in which she finds herself.

Vagabond (Vagabundo), 1957

This picture is, to my mind, one of the best that I've painted. It's a design of a vagabond outfit, but it's about a vagabond who's not free. It's a very practical and comfortable outfit, for movement it has front-wheel drive, if he lifts the walking stick it stops. The suit can be hermetically sealed at night, it has a little door that can be

locked; some parts of the outfit are wooden, but, as I say, the man has not been freed. On one side of the outfit there's a nook that is the equivalent of a living room, a portrait is hanging there with three books, on his breast he wears a flowerpot where he's raising a rose, a finer and more delicate plant than what he finds in those forests, but he needs the portrait, the rose (a yearning after a little garden at home) and his cat. He isn't genuinely free.

Portrait of Doctor Ignacio Chávez (*Retrato del doctor Ignacio Chávez*), 1957
This is the painting I made for Doctor Chávez. The character in this crystalloidal grotto is the doctor himself (I took his most characteristic features but didn't attempt to do a portrait). I've dressed him in somewhat priestly garb to suggest that his profession is perhaps a kind of priesthood. In his hand he holds a key. The characters who are coming down that narrow pass have a tiny door where their heart is and as they pass by he winds them up. These characters are very unreal, more like marionettes, and move by means of some cords that run from little wheels on their elbows and joints up to the stars of the constellation of the crab. According to the ancient books of physiology (which I consulted), that constellation rules over illnesses and affairs of the heart.

Be Brief (*Sea usted breve*), 1958
Nothing much in particular is happening here. That lady is strolling along with a talisman in her hand, her hat is a little cloud that keeps leaving scraps behind itself, on the first story of the house in back, on the right, lives a horse.

Microcosmos or Determinism (*Microcosmos o Determinismo*) 1959
This painting is part of the project I did when they commissioned those murals from me for the Oncology Pavilion, which I ultimately didn't want to carry out.

Up above you see a small part of the zodiac, inside the little ships are, from left to right, Scorpio, Sagittarius, and Capricorn (one assumes that the rest of the zodiac remains outside the painting). As you can see, with their hands they're pulling at celestial substances, which afterward get out through the ships' exhaust pipes, each of those exhaust pipes has the shape of its sign, the celestial substances fall down to a sort of temple, where after sufficient seething and boiling and chemical transformation, the various creatures are produced which leave and are distributed around the world. As they leave all of them are white and are wrapped in a shared white vestment like a celestial placenta and as they become individuals they take on color. On the one hand I try to suggest a kind of determinism, and on the other of harmony, this latter by means of the astral motor that moves the little ships and is *one*. In the part of the project I didn't paint in this picture, the lack of harmony was a horrifying ship that obeyed *two* central motors, etc.

Unexpected Visit (*Visita inesperada*), 1958
This woman was expecting a guest, but not that one, and she's extremely startled, and as she stretches out her hand behind her as if asking for help, her wish comes true and from the wall a hand emerges which she grasps.

Under the table there's a concealed well into which she habitually casts her victims, but she won't be able to cast this one who's arriving, since he doesn't even fit.

The animal to the right, below, was formed from a composite mass of dried leaves.

Hirsute Locomotion (Locomoción capilar), 1959
These gentlemen are detectives, well disguised so as to go unobserved, their beards also serve as their means of locomotion. The man who is looking out the window uses his beard to abduct that poor frightened young woman, who stands around the corner.

Character (Personaje), 1959
This one is fleeing with his captive, as is obvious. Because of the velocity, some of the motifs printed on the lower part of his robe get left behind.

Encounter (Encuentro), 1959
This poor woman, full of curiosity and expectation as she opened that little coffer, encounters her own self. In the background, on the shelves, there are more little coffers and who knows whether on opening them she will find something new.

Encounter (Encuentro), 1959
This statue got down from the pedestal to keep the rendezvous he had with the woman who is opening the door for him and who is made of fire, just the thing for the statue, who is cold.
 A neighbor woman across the way is watching, scandalized.

Ascent to Mount Analogue (Ascensión al monte análogo), 1960
I can't remember if I've already sent you this photo.

As you see, that character is heading upstream, alone, on an extremely fragile little piece of wood and his own garments serve as his sail.

It is the effort of those who seek to rise to another spiritual level.

Woman Leaving the Psychoanalyst (*Mujer saliendo del psicoanalista*), 1960
This lady leaves the psychoanalyst tossing her father's head into a well (as is proper upon leaving the psychoanalyst). In the basket she carries other psychological waste: a clock, symbol of the fear of arriving late, etc. The doctor's name is Dr. FJA (Freud, Jung, Adler).

Mimicry (*Mimetismo*), 1960
This is a disturbing case of mimicry. That lady sat pensive and motionless for so long that she's turning into an armchair, her flesh has become the same as the armchair's fabric and her hands and her feet are already as if they'd been lathed. The furniture is getting bored and the armchair is biting the table, the chair in back is investigating the contents of the drawer, and the cat that went out hunting undergoes shock and amazement on its return when it sees the transformation.

Toward the Tower (*Hacia la torre*) The triptych's first panel, 1960
The girls are leaving their beehive-house to go to their job. They're being guarded by the birds so that none can escape. Their eyes are as if hypnotized, they hold their knitting needles like handlebars. Only the girl in front resists the hypnosis.

Embroidering the Earth's Mantle (Bordando el manto terrestre) The triptych's second panel, 1961
Under the orders of the Great Master, they're embroidering the Earth's mantle, seas, mountains, and living things. Only the girl has woven a ruse in which she is seen beside her beloved.

The Escape (La huida) The triptych's third panel, 1961
As a result of her ruse she manages to elope with her beloved, and they set out in a special vehicle, across a desert, toward a grotto.

The Call or *She Who Is Called (La llamada)*, 1961
A woman, brilliant and electric, full of light, brimming with energy and inner radiance, purposefully heeds a mysterious call. The street is embroidered with silent stone witnesses, oblivious to what is happening and incapable of understanding it. She is bound to the cosmos and its designs by means of her hair, the alchemist's mortar hangs from her neck, though not for mixing substances and conspiracies, but instead for transcending her own self.

Discovery of a Mutant Geologist (Descubrimiento de un geólogo mutante), 1961
In a landscape devastated by the atomic bomb, a geologist, mutant because of the radiation, examines a gigantic flower. The geologist is loaded down with a very interesting instrument-laboratory.

Disobedient Plant (Planta insumisa), 1961
This scientist is experimenting with various plants and vegetables. He's puzzled because there's a rebellious plant. All the plants are already sending out tendrils in the shape of mathematical figures and formulas except for one that insists on producing a flower, and

the only mathematical tendril it sent out at first, and which falls on the table, was very frail and withered and, moreover, wrong, since it says "two and two are almost four."

Every hair of the scientist is a mathematical formula.

Phenomenon of Weightlessness (Fenómeno de ingravidez), 1963
The Earth escapes from its axis and its center of gravity to the great surprise of the astronomer, who tries to keep his balance standing with his left foot in one dimension and his right in another.

EDITOR'S NOTES

"VERY EARLY ONE MORNING"

The story may have its origins in Varo's occasional trips by plane to the Pacific coast to visit Gerardo Lizarraga and his family, who had moved to a ranch near Acapulco in the early 1950s (Xabier Lizarraga Cruchaga, email message to the translator, 12 August 2022).

THE KNIGHT CASILDO MARTÍN DE VILBOA

Varo wrote this story to accompany her *Portrait of Juan Martín* (*Retrato de Juan Martín*), painted in 1960. In it her gallerist, Juan Martín, Is depicted In the ceremonial garb of a medieval knight (See Ovalle, 363).

"Rodriga" is one of Varo's given names.

"MY DEAREST SIR, I HAVE LET A PRUDENT AMOUNT OF TIME GO BY"

The handwritten copy in Varo's notebook has no salutation or closing, but the letter may have been directed to César Moro, the Peruvian poet and artist. In the Remedios Varo Archive there is a letter dated 11 June 1953 in which Moro seems to respond to her playful reproach that he has forgotten her: "I have never forgotten you . . . I constantly talk about you, and my friends know you like family." Moro lived in Mexico City from 1938 to 1948 and then returned to Lima, Peru, where he died in 1956. See Karla Segura Pantoja,

Le surréalisme déplacé: Inventaire, établissement et étude des œuvres des surréalistes exilés au Mexique. CY Cergy Paris Université, 2018. https://hal .science/tel-03705855, 244–245.

Varo's visual poems include these words:

a. swallow
 young lady
 butterfly
b. Almond tree in bloom
 Three fourteen fifteen

"WHAT I'M READING NOW, GERARDO"

The addressee is unidentified in the copy in Varo's notebook. The "Gerardo" of the letter's first line is almost surely the artist Gerardo Lizarraga (1905– 1982), Varo's first husband. Lizarraga arrived in Mexico City in 1942 as a political refugee and lived there for the rest of his life.

"O ADMIRABLE AND ELUSIVE GODDESSES!"

The handwritten copy in Varo's notebook has no salutation or closing. Walter Gruen believed the letter was addressed to Juliana González and Mercedes de la Garza, young friends of the artist. See Castells, *El tejido de los sueños*, 105.

"DEAR STRANGER"

YOU'RE A FRIEND OF EDWARD'S: Edward James (1907–1984), a wealthy English patron of the arts, was an important collector of works by Leonora

EDITOR'S NOTES

Carrington, Remedios Varo, and Kati Horna, among other Surrealists. He traveled widely and lived for long stretches of time in Mexico.

"DEAR DR. ALBERCA"

DOCTOR ALBERCA: Román Alberca Lorente (1903–1966), a noted psychiatrist and professor at the University of Valencia who was a former medical school classmate of Varo's older brother Rodrigo. Varo began to exchange letters with Dr. Alberca in 1959. See Beatriz Varo, *Remedios Varo: En el centro del microcosmo*, 100–102.

"DEAR MR. GARDNER"

MR. GARDNER: the English author Gerald Brosseau Gardner (1884–1964), a popularizer of Wicca. See Tere Arcq, "Mirrors of the Marvellous" in *Surreal Friends: Leonora Carrington, Remedios Varo and Kati Horna* (Farnham: Lund Humphries, 2010), 106. The book Varo is referring to is most likely *Witchcraft Today* (1954) or *The Meaning of Witchcraft* (1959).

TOLOACHE: Variously known in English as devil's trumpets, moonflowers, jimson week, devil's weed, hell's bells, thorn-apple. "Jimson weed is a powerful herb, and in small amounts, it's used to control men and women and to settle them down to stay home and not fool around. Usually, they don't know that they are being given the substance, which keeps them docile, or *mansitos*." Antonio Zavaleta and Alberto Salinas, *Curandero Conversations: El Niño Fidencio, Shamanism and Healing Traditions of the Borderlands* (Bloomington, IN: AuthorHouse, 2009), 197.

"MONSIEUR"

The original letter was written in French.

TO THE INCOMPARABLE DOÑA ROSA DE LOS ALDABES

ROSA ZABARAIN DE LOS ALDABES: a member of the Spanish exile community in Mexico City. She was a friend of Varo's and an expert dressmaker.

"MEXICO CITY, 11 NOVEMBER 1959. DEAR FRIEND"

The original letter was written in French.

RECIPES AND ADVICE

The character Felina Caprino-Mandrágora (Varo's alter-ego) reappears in the exquisite corpse narrative.

"To Dream You Are King of England" breaks off abruptly. The rest of the recipe was presumably burned up in the bonfire that consumed the intrepid knight Igor López Smith.

CAST OF CHARACTERS

Several characters in the list appear in the two stories that make up Varo's side of the exquisite corpse narrative that follows. The other characters may belong to Leonora Carrington's side of the narrative, which has not yet come to light.

"IT'S FOUR IN THE MORNING"

In the dream related by Felina Caprino-Mandrágora, Benjamin Péret is the inspiration for Benjamin Pérez, the old friend Felina runs into on the Paseo de la Retorta (Paseo de la Reforma) who operates a carrier-pigeon business. Kaplan points out that Varo is referencing a story by Péret, "La Fleur de Napoléon," in which carrier-pigeons are used to smuggle cocaine. See "The Flower of Napoléon," in Benjamin Péret, *The Leg of Lamb: Its Life and Works*, trans. Marc Lowenthal (Wakefleld Press, 2011), 32–36.

The last five paragraphs of "It's Four in the Morning" were written in French.

"JAVIER'S BIRTHDAY"

JAVIER: Xabier Lizarraga Cruchaga, the son of Gerardo Lizarraga and the photographer Ikerne Cruchaga. "Javier" is the Castillian form of the Basque name "Xabier."

The English translation of a fragment from Jorge Luis Borges's "Deutsches Requiem" is by Andrew Hurley.

"I WENT TO VISIT JAVIER AND AMAYA"

AMAYA: Amaya Lizarraga Cruchaga, the first-born daughter of Gerardo Lizarraga and Ikerne Cruchaga.

"I'M BATHING AN ORANGE KITTEN"

In the handwritten manuscript, the last word of the narrative was erased.

LEONORA: Leonora Carrington.

JUAN: Juan Martín, Remedios Varo's gallerist after 1960.

"WE WERE ALL LIVING TOGETHER IN THE SAME HOUSE"

GABI AND PALITO: Gabriel Weisz Carrington and Pablo Weisz Carrington, the sons of Leonora Carrington and the Hungarian photographer Emerico (Chiki) Weisz.

BILL: an unidentified friend of Varo's.

"SUNDAY. WE'RE IN THE HOUSE OF THE BAL Y GAYS FAMILY"

BAL Y GAYS: Spanish composer and musicologist Jesús Bal y Gays (1905–1993) and his wife, the Spanish pianist Rosita García Ascot (1902–2002), part of the community of Spanish Republicans in exile in Mexico City. In 1955, they opened on the Paseo de la Reforma the Galería Diana, where in that same year Remedios Varo was the stand-out participant in the group show *6 Pintoras*.

MARIO STERN: (1936–2017) Mexican composer and music professor.

"EVA AND I WERE SUPPOSED TO TAKE A VERY LONG TRIP"

EVA: Eva Sulzer (1902–1990), Swiss photographer, filmmaker, and patron of the arts. In 1939, Sulzer settled in Mexico City with artists Wolfgang Paalen and Alice Rahon, with whom she had been traveling down the Pacific Northwest to Mexico when World War II broke out. Her photographs and

articles appear in *Dyn*, the influential avant-garde art journal founded by Paalen. Sulzer's friendship with Varo began soon after the artist's arrival in Mexico (the 1943 gouache *Transmisión ciclista con cristales* is inscribed to Sulzer), and they both frequented Gurdjieff circles in Mexico (see Arcq, "In Search of the Miraculous," 20–86). Sulzer remained in Mexico for the rest of her life.

PAALEN: Wolfgang Paalen (1905–1959), German-Austrian painter and sculptor, editor of the Surrealist art magazine *Dyn*, published from 1942 to 1944.

MRS. GELMAN: Natasha Gelman (1911–1998), wife of Mexican movie producer Jacques Gelman (1911–1984). The Gelmans were noted art collectors.

INCANTATION

The poem has no title. The Spanish reads as follows:
Tetratitroluna
Lunatitrotetra
Esparciluce
mi soledad
¡Fango!
Huracaninoctur
No
Alma desmelenada
Astro luce lice
Mi tempestad
¡Oh rulseñor espera!

"HAIR SALON—PSYCHOANALYST"

Comments by Walter Gruen (found in the Remedios Varo Archive) about this page:

"Ideas to carry out:

Hair salon-psychoanalyst (cerebral strip being ironed). It's related to a project [Remedios Varo] described to me about a psychoanalytic session where you see the patient with an opening in his head, from which an accordion-like tape emerges that the analyst presses with an iron. There's a sketch in notebook No. . . . (This was a recent idea and wasn't carried out.)

2. Vegetal Cathedral (she crossed it out because it was painted)

3. Staining and peeling identical with the man passing by . . . (she crossed it out because it was painted)

4. Créature qui brode l'étoffe qui couvre la terre (Embroidering the Earth's Mantle, painted)

5. The Bearded Men Who Roll Along (Painted, *Hirsute Locomotion*)

6. Always the blade of light that gives birth to a creature by means of the goblet of a kind of still life (I don't know what this is)

Le rêve par la diagonale."

COMMENTS BY REMEDIOS VARO ON SOME OF HER PAINTINGS

With one exception—*Portrait of Barón Ángelo Milfastos as a Boy*, which she addressed to the Mexican artist Juan Soriano—Varo's comments were handwritten on the reverse of photos sent to her brother Rodrigo.

SELECTED BIBLIOGRAPHY

Arcq, Tere. "Mexico City." In *Surrealism Beyond Borders*, edited by Stephanie D'Alessandro and Matthew Gale. New York: Metropolitan Museum of Art, 2021.

Arcq, Tere. "In Search of the Miraculous: The Esoteric Key." Trans. Michelle Suderman. Orellana 20–86.

Arcq, Tere. "Mirrors of the Marvellous: Leonora Carrington and Remedios Varo." Trans. Michelle Suderman. Raay, 98–115.

Castells, Isabel. *Cartas, sueños y otros textos*. Mexico City: Ediciones Era, 1997.

Castells, Isabel. *El tejido de los sueños: Obra escrita*. Seville: Editorial Renacimiento, 2023.

Haskell, Caitlin, and Tere Arcq, eds. *Remedios Varo: Science Fictions*. Chicago: Art Institute of Chicago, 2023.

Kaplan, Janet. *Unexpected Journeys: The Art and Life of Remedios Varo*. New York: Abbeville Press, 1988.

León, Luis Miguel, and Marisol Argüelles, eds. *Adictos a Remedios Varo: Nuevo Legado 2018*. Mexico City: Instituto Nacional de Bellas Artes, Museo de Arte Moderno, 2018.

Mendoza Bolio, Edith. *A veces escribo como si trazase un boceto: Los escritos de Remedios Varo*. Madrid: Iberoamericana, 2010.

Orellana, Margarita de, ed. *Five Keys to the Secret World of Remedios Varo*. Translated by Michelle Suderman, Lorna Scott Fox, Richard Miszka, and Quentin Pope. Mexico City: Artes de México, 2008.

Ovalle, Ricardo, and Walter Gruen, eds. *Remedios Varo: Catálogo Razonado—Catalogue Raisonné*. 4th edition. Translated by Susan Beth Kapilian and Laura Gorham. Mexico City: Ediciones Era, 2008.

Raay, Stefan van, Joanna Moorhead, and Teresa Arcq. *Surreal Friends: Leonora Carrington, Remedios Varo and Kati Horna*. Farnham: Lund Humphries, 2010.

Varo, Beatriz. *Remedios Varo: El centro del microcosmos*. Mexico City: Fondo de Cultura Económica, 1990.

Varo, Remedios. [Hälikcio von Fuhrängschmidt]. *De Homo Rodans*. Mexico City: Calli-Nova, 1970.

Margaret Carson's translations include Remedios Varo's *Letters, Dreams & Other Writings* and Sergio Chejfec's *My Two Worlds*. She teaches at Borough of Manhattan Community College, The City University of New York.

THE ENVELOPE-SILENCE

A Surrealist Library

1. *The Leg of Lamb: Its Life and Works*, Benjamin Péret

2. *The Trumpets of Jericho*, Unica Zürn

3. *The Arthritic Grasshopper: Collected Stories, 1934–1944*, Gisèle Prassinos

4. *Letters, Dreams & Other Writings*, Remedios Varo (out of print)

5. *The Subversion of Images*, Paul Nougé

6. *Rogomelec*, Leonor Fini

7. *The Voyage of Horace Pirouelle*, Philippe Soupault

8. *On* Homo rodans *and Other Writings*, Remedios Varo